NEW DESIGN:
BERLIN

ROCKPORT

NEW DESIGN
BERLIN

editor: **James Grayson Trulove**

THE EDGE OF GRAPHIC DESIGN

GLOUCESTER MASSACHUSETTS

ROCKPORT PUBLISHERS

Copyright © 2000 by Rockport Publishers, Inc.

All rights reserved. No part of this
book may be reproduced in any form
without written permission of the copyright
owners. All images in this book have
been reproduced with the knowledge and prior
consent of the artists concerned
and no responsibility is accepted by
producer, publisher, or printer for any
infringement of copyright or otherwise,
arising from the contents of this
publication. Every effort has been made
to ensure that credits accurately comply
with information supplied.

FIRST PUBLISHED IN THE UNITED
STATES OF AMERICA BY:
Rockport Publishers, Inc.
33 Commercial Street
Gloucester, Massachusetts 01930-5089
Telephone: (978) 282-9590
Facsimile: (978) 283-2742

ISBN 1-56496-659-3
10 9 8 7 6 5 4 3 2 1

Design: Stoltze Design
Cover Image: Photodisc

Printed in China

Acknowledgments

I'd like to express my gratitude to Bele Ducke, a graphic designer and graduate of the Hochschule der Künste Berlin, for her valuable guidance in identifying graphic designers in Berlin. I am grateful to Steel H. Colony for skillfully organizing my many Berlin studio visits undertaken in the preparation of this book. Special thanks also to the staff at Rockport Publishers including Jack Savage and Cathy Kelly.

Having personally met with all of the graphic design firms featured in New Design: Berlin, I would like to thank all the individuals associated with these firms for their many kindnesses during those visits, and for their prompt and tireless attention to my many requests. The work presented in these pages is a testament to the extraordinary energy and creativity that defines graphic design in Berlin as we begin a new millennium.

CONTENTS

Introduction	**8**
Adler & Schmidt	**16**
Anna B. Design	**24**
atelier: [doppelpunkt]	**30**
Bauer + Möhring	**40**
cyan	**44**
de'blik	**54**
Die Gestalten Verlag	**58**
e27	**66**
eboy	**70**
fernkopie	**76**
gewerk	**86**
grappa blotto	**92**
grappa.dor	**78**
Hayn/Wellemeit	**108**

im stall	**112**
K/PLEX	**118**
Leonardi.Wollein	**126**
Moniteurs	**134**
Ott + Stein	**142**
Pixelpark	**150**
Scholz & Friends Berlin	**160**
Skop	**168**
Ständige Vertretung	**174**
stereobloc	**180**
studio adhoc	**188**
Typoly	**194**
About the Author	**199**

As this is being written, the tenth anniversary of the fall of the Wall is being celebrated in Berlin and in democratic countries around the world. The energy in the city is palpable. Everywhere there is change. Berlin has once again become the political capital of a united Germany. A visitor ascending the circular ramp in the glass dome atop the Reichstage, designed by the British architect Sir Norman Foster, can see scores of construction cranes dotting Berlin's eastward skyline as the world's architectural stars attempt to make Berlin an architectural capital as well.

For a close-up look at what is currently billed as the largest construction site in Europe—Potsdamer Platz—a giant red three-story so-called INFO BOX has been erected on a temporary site in the middle of it all. Exhibits in the INFO BOX tell the story of where all of this construction is headed, complete with computer images and models of how it will eventually look. Several buildings have already been completed including the Daimler-Benz building by Renzo Piano, where a "construction crane ballet" was held at the building's topping out ceremony. Projects by architects Jose Rafael Moneo, Richard Rogers, and Arata Isozaki, among others are also blooming around Potsdamer Platz.

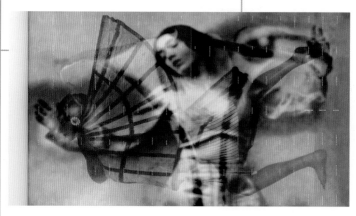

Poster
Designer:
Dieter Feseke, grappa blotto

The physical scars of the wall have disappeared rapidly; it is often difficult to know whether you are in the East or the West. Remarkably, when a group of young designers are asked to trace the path of the wall on a contemporary map of the city, an argument erupts as to its exact location. In one sense, it is as if a marriage has taken place between a couple of mismatched eras--one 40 years older than the other--with the younger East Berlin bringing a renewed vitality to the other. Many of the trendiest spots have blossomed in eastern districts such as Mitte, an area that bustles with the energy akin to New York's Soho in the 1970s and early 1980s; and Prenzlauer Berg where funky bars and cafes, art galleries and performance spaces line many of the streets. There, rents are still cheap and space generous so artists, writers, and designers of all types are flocking into converted factories and other industrial spaces in courtyards tucked deep within the large square blocks that are characteristic of the East's urban grid.

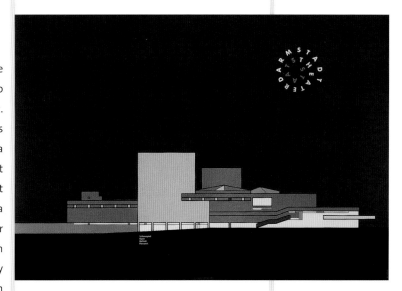

Poster
Designers: Ott + Stein

In a sense, Berlin has become a laboratory for experiment, in architecture, painting, graphic design, and urban planning. In commemoration of the tenth anniversary of the fall of the Wall, several exhibits have been held in Berlin and elsewhere chronicling the changes rendered by a decade of experimentation. One exhibition, "Children of Berlin: Cultural Developments 1989-99" seen at PS1 in New York, featured the work of Berlin's artists, new media pioneers, architects, and others enmeshed in the cultural life of the city. An installation by artist Monica Bonvicini, "A Violent, Tropical, Cyclonic Piece of Art Having Wind Speeds of or in Excess of 75 Miles per Hour," required the viewer to walk between opposing, powerful electric fans blowing hurricane-like winds. After visiting

Poster
Designer: fernkopie

scores of graphic design studios in Berlin, this installation seems an apt metaphor for the creativity, energy, and intensity that suffuses the current graphic design community. While there are strong graphic design traditions in Berlin, all but one of the studios presented in this book were founded within the last 10 years; fully half were started in just the past five. Virtually all the youngest firms are in the East, the epicenter of this creative hurricane.

The merging of Berlin's two sectors, the instant introduction of computers in the East in the early 1990s, the flowering of the Internet (bringing with it new graphic design ideas from all over the world), and the rapidly expanding client base as more companies move into the new capital, have all dramatically influenced Berlin's graphic designers and provided the capital for the phenomenal growth of new studios.

Poster
Designers: grappa blotto

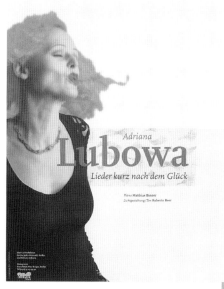

Poster
Designer: stereobloc

Nevertheless, many graphic designers who work primarily in the city's cultural sectors complain that the government is spending too much money on architecture and infrastructure while reducing allotments to museums, theaters, and other arts organizations. As a result, corporations are becoming bigger players in the cultural scene much to the dismay of many designers who are forced to integrate corporate logos into the otherwise pristine posters, brochures, and invitations for openings and performances.

Of course, for those designers who worked in the East before the fall, adequate budgets for their work were a rarity. The resourceful and creative graphic designers who formed grappa in the late 1980s were inspired rather than restrained by the lack of money. Their low grade paper stock and two-color printing yielded designs that had an edgy, minimalist quality that was widely copied in the West. Since its founding, grappa's original partners split into grappa blotto, grappa.dor and cyan. While the design philosophies and esthetics may differ among the three, they still mainly work for the same cultural organizations creating books and posters that are as visually dynamic as any graphic design created in Berlin today.

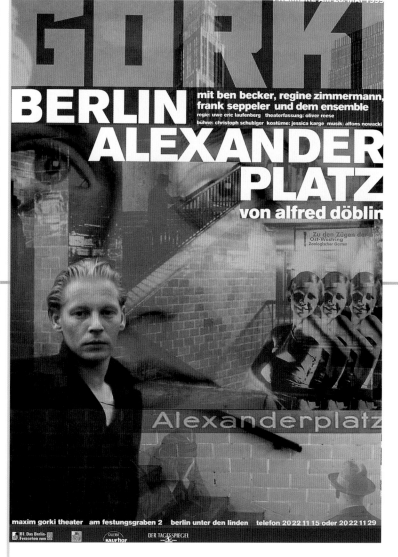

Poster
Designers: grappa.dor

Film poster
Designer: Anna Berkenbusch

Elsewhere, the emergence of Berlin as a world capital and a growing client base is creating a few firms with multimillion-dollar billings and international client lists. Scholz & Friends has become the first all-German advertising agency, embracing the culture of both the East (where it got its start and still has its offices) and the West where most of its clients are based. On the tenth anniversary of the unification and just eight years after its founding, Pixelpark, the creator of commercial web sites, became a publicly traded company. It now has 11 offices in six countries.

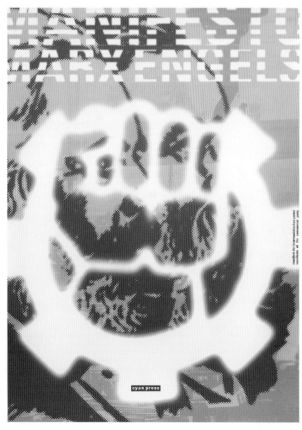

Book cover
Designers: cyan

Corporate image campaign
Designers: Adler & Schmidt

In the midst of all of this growth and change, Berlin has been blessed with a first rate design school, the Hochschule der Künste where many of the city's designers receive their training. In the case of studios such as Adler & Schmidt and Bauer + Möhring, HdK was the place where the eventual partners first met.

Running through much Berliner graphic design is a long-standing interest in typography, both as a design element and in its creation. Font design is an important component in the work of many of Berlin's studios. The designers at Moniteurs created their own--now widely recognized--typeface label, *Face2Face* and their book *emotional_digital*, published in 1999 is becoming a standard reference on contemporary type design. Similarly, Ott + Stein, internationally recognized for the use and placement of type in their poster designs, published the definitive anthology of type designers, *Typography—When, Who, How* in 1998. Alesio Leonardi of Leonardi-Wollen is a well-known Italian designer whose fonts are available internationally. eboy, the hip web designer and digital illustrator, has created fonts inspired by their fascination with pop culture.

Posters are another of the city's strong design traditions and are a staple for many firms. Anna Berkenbusch's film posters can be seen at mainstream and experimental movie houses throughout Berlin. Over the last 20 years, Nicolaus Ott and Bernard Stein have created more than 600 posters for architects, artists, publishers, and exhibition planners. Their designs have established an unmistakable formal language that has made a crucial mark on the public image of Berlin's cultural scene. The range of the poster design

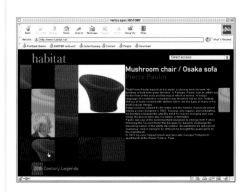

Web site
Designers: Pixelpark

Zimmermann. Druckerei. Permedia

Corporate identity campaign
Designers: Leonardi.Wollein

is wide. The lyrical posters created by fernkopie stand in stark contrast to the modernist architectural ones by Adler and Schmidt.

Whether it is font or poster design, web sites or corporate image campaigns, there is an unmistakable wit and energy emerging from Berlin's graphic design studios. Drawing upon the modernists and avant garde vocabulary from the pre-war days when Berlin was a design leader, the 26 graphic designers in *New Design: Berlin* are pushing this extraordinary city into the forefront of graphic design yet again.

Book cover
Designers: Die Gestalten

PRINCIPALS: Hans-Peter Schmidt, Florian Adler
FOUNDED: 1989

Pfalzburger Strasse 43-44
10717 Berlin (Wilmersdorf)
TEL (49) 30 86 00 07 0
FAX (49) 30 86 00 07 20
EMAIL: buero@adler-schmidt.de
WEB: www.adler-schmidt.de

ADLER & SCHMIDT

Highly functional and economical design solutions growing out of a process of refining all relevant aspects of a particular communication to its very essence underscore the design philosophy of Adler & Schmidt. Founded in 1989 by Hans-Peter Schmidt and Florian Adler, the studio was an outgrowth of a collaboration the two began while training with Professor Helmut Lortz at the famed Hochschule der Künste in Berlin. Today, the partnership has expanded into a team of ten designers working in a loft on the top floor of a former warehouse in the Wilmersdorf district of Berlin.

While the design activities of Adler & Schmidt cover a wide range of projects a major focus of their work is in the fields of architecture and urban design where their straight forward design esthetic is most notable. In 1992, the Berlin Senate Department of Construction, Housing and Transport initiated a series of public lectures and debates on topical issues related to the architecture and urban development in Berlin after reunification of the city. Adler & Schmidt were chosen to create posters and official invitations for these events. Now with more than 45 designs to their credit, they have succeeded in creating a unique and unmistakable visual language for this series that reflects the diversity of issues which have come to dominate the architectural debate in Berlin in the 1990s.

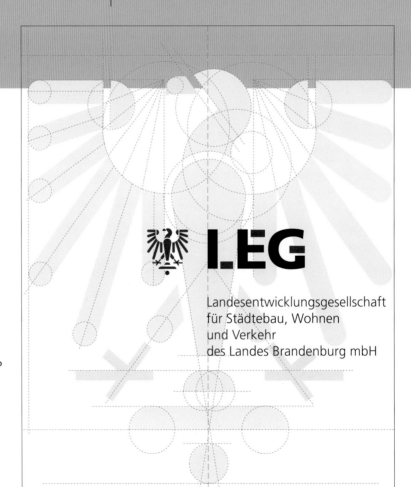

LEG

Landesentwicklungsgesellschaft
für Städtebau, Wohnen
und Verkehr
des Landes Brandenburg mbH

Based on the heraldic animal of the State of Brandenburg, this logo was created for the Landesentwicklungsgesellschaft of the State of Brandenburg as part of a corporate design scheme.

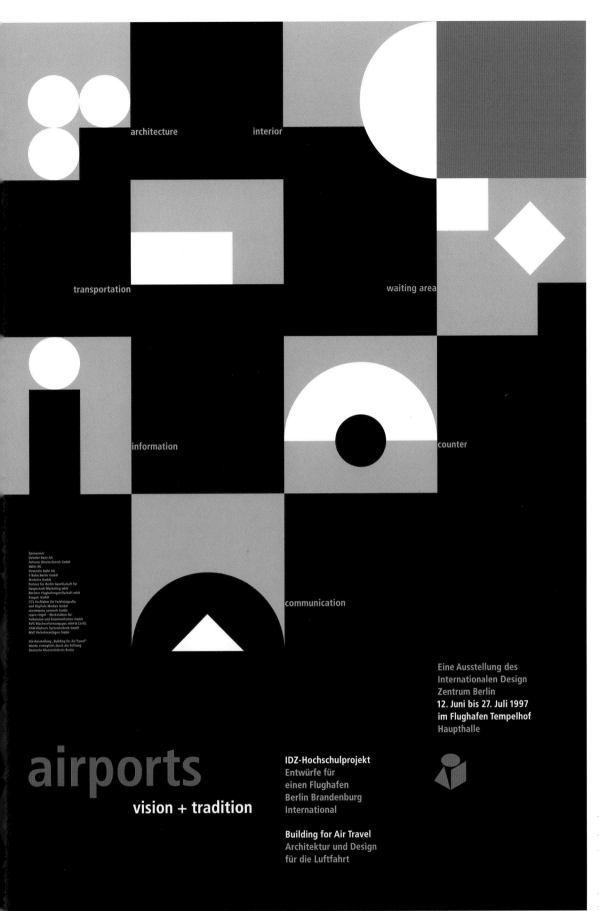

architecture

interior

transportation

waiting area

information

counter

communication

Sponsoren:
Daimler-Benz AG
Aritranz (Deutschland) GmbH
debis AG
Deutsche Bahn AG
S-Bahn Berlin GmbH
Moduline GmbH
Partner für Berlin Gesellschaft für
Hauptstadt-Marketing mbH
Berliner Flughafengesellschaft mbH
Etagair GmbH
CCS Fachlabor für Farbfotografie
und Digitale Medien GmbH
movimento network GmbH
repro ringel – Werkstätten für
Farbvision und Kommunikation GmbH
BVG Blucherformanzeigen mbH & Co KG
VAW Aluform Systemtechnik GmbH
Wall Verkehrsanlagen GmbH

Die Ausstellung „Building for Air Travel"
wurde ermöglicht durch die Stiftung
Deutsche Klassenlotterie Berlin

Eine Ausstellung des
Internationalen Design
Zentrum Berlin
**12. Juni bis 27. Juli 1997
im Flughafen Tempelhof
Haupthalle**

airports
vision + tradition

IDZ-Hochschulprojekt
Entwürfe für
einen Flughafen
Berlin Brandenburg
International

Building for Air Travel
Architektur und Design
für die Luftfahrt

This poster was created for an
exhibition of airport architecture
and design for the International
Design Center Berlin. The design
makes use of a number of abstract-
ed pictograms representing the
various themes of the exhibition.

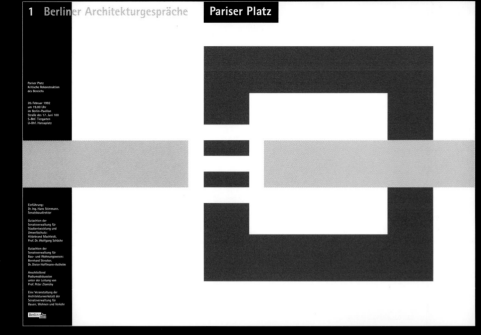

Pariser Platz

Pariser Platz
Kritische Rekonstruktion
des Bereichs

20. Februar 1992
um 19.00 Uhr
im Berlin-Pavillon
Straße des 17. Juni 100
S-Bhf. Tiergarten
U-Bhf. Hansaplatz

Einführung:
Dr. Ing. Hans Stimmann,
Senatsbaudirektor

Gutachten der
Senatsverwaltung für
Stadtentwicklung und
Umweltschutz:
Hildebrand Machleidt,
Prof. Dr. Wolfgang Schäche

Gutachten der
Senatsverwaltung für
Bau- und Wohnungswesen:
Bernhard Strecker,
Dr. Dieter Hoffmann-Axthelm

Anschließend
Podiumsdiskussion
unter der Leitung von
Prof. Peter Zlonicky

Eine Veranstaltung der
Architekturwerkstatt der
Senatsverwaltung für
Bauen, Wohnen und Verkehr

Berlin

Kulturforum

Wie lang ist die
Haltbarkeit von
Architekturkonzepten?

14. Mai 1997
um 19.00 Uhr
im Berlin Pavillon
Straße des 17. Juni 100
S-Bhf. Tiergarten
U-Bhf. Hansaplatz

Eröffnung:
Senator Jürgen Klemann

Gesprächsleitung:
Senatsbaudirektorin
Prof. Barbara Jakubeit

Teilnehmer:
Wilfried Wang, Direktor des
Deutschen Architekturmuseums,
Frankfurt/Main (Einführung)
Dr. Elmar Weingarten,
Intendant des Philharmonischen
Orchesters, Berlin
Prof. Dr. Wolf–Dieter Dube,
Generaldirektor der Staatlichen
Museen, Berlin
Bernhard Schneider, Architekt,
Berlin
Gabriele Dolff–Bohnekämper,
Landesdenkmalamt Berlin
Edgar Wisniewski, Architekt,
Berlin
Ivan Reimann, Architekt, Berlin

Eine Veranstaltung der
Architekturwerkstatt in der
Senatsverwaltung für
Bauen, Wohnen und Verkehr

Berlin

46 Berliner Architekturgespräche

Tradition und Moderne

Vorwärts auf dem Weg
in die Vergangenheit?

14. Oktober 1999
um 19.00 Uhr
im Stadthaus, Bärensaal
Klosterstraße 47,
Eingang Jüdenstraße 34–42
10179 Berlin

Moderation:
Prof. Barbara Jakubeit,
Senatsbaudirektorin

Teilnehmer:
Rüdiger Patzschke,
Architekt, Berlin
Prof. Leon Krier,
Architekt, Claviers
Prof. Miroslav Sik,
Architekt, Zürich
Prof. Hans Kollhoff,
Architekt, Berlin
Rainer Haubrich,
Journalist, Berlin
Dr. Dieter Bartezko,
Journalist, Frankfurt

Eine Veranstaltung der
Architekturwerkstatt der
Senatsverwaltung für
Bauen, Wohnen und Verkehr

Berlin

35 Berliner Architekturgespräche

Bauakademie

Mythos oder
Investitionsrealität?

2. September 1997
um 19.00 Uhr
im Berlin Pavillon
Straße des 17. Juni 100
S-Bhf. Tiergarten
U-Bhf. Hansaplatz

Eröffnung:
Senator Jürgen Klemann

Gesprächsleitung:
Senatsbaudirektorin
Prof. Barbara Jakubeit

Teilnehmer:
Gisbert Dreyer,
HYPO-REAL, München
Roger Dienes,
Architekt Basel
Walter Noebel,
Architekt Berlin
Prof. Josef-Paul Kleihues,
Architekt Berlin
Prof. Klaus Töpfer,
Bundesbauminister Berlin/Bonn
(angefragt)

Eine Veranstaltung der
Architekturwerkstatt in der
Senatsverwaltung für
Bauen, Wohnen und Verkehr

Berlin

In 1992, the Berlin Senate
Department of Construction,
Housing, and Transport initiated a
series of public lectures and debates
on topical issues related to
architecture and urban development
in Berlin after reunification of the
city. With a total of more than 45
designs for posters and official
invitations, Hans-Peter Schmidt and
Florian Adler have created a unique
and unmistakable visual language
for this series of events, reflecting
the diversity of issues that have
come to dominate the ongoing
architectural debate in Berlin.

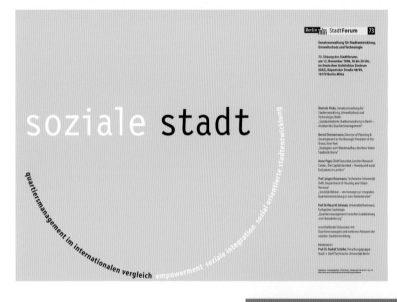

In the past few years, the "StadtForum" (City Forum)—an offspring of the Berlin Senate Department of Urban Development, Environmental Protection, and Technology—has become a public workshop for ideas about urban development policy in Berlin. In a series of posters for "StadtForum", the designers have developed a clear, strictly typographic visual imagery.

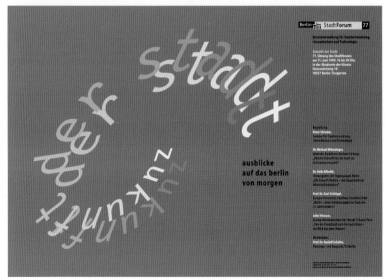

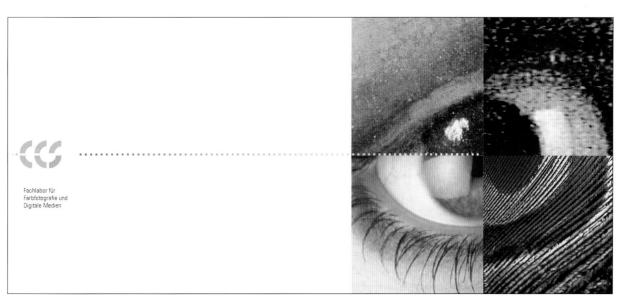

Fachlabor für
Farbfotografie und
Digitale Medien

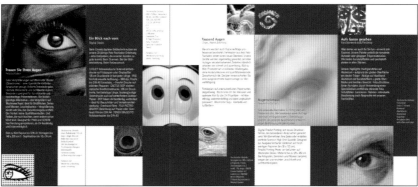

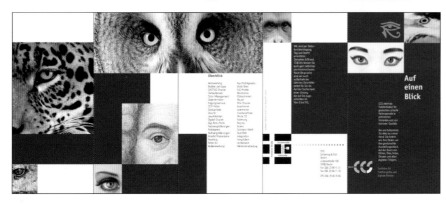

The visual imagery for this corporate image campaign for a company specializing in large-format digital color printing consists of three distinct elements: eyes, vision, and color.

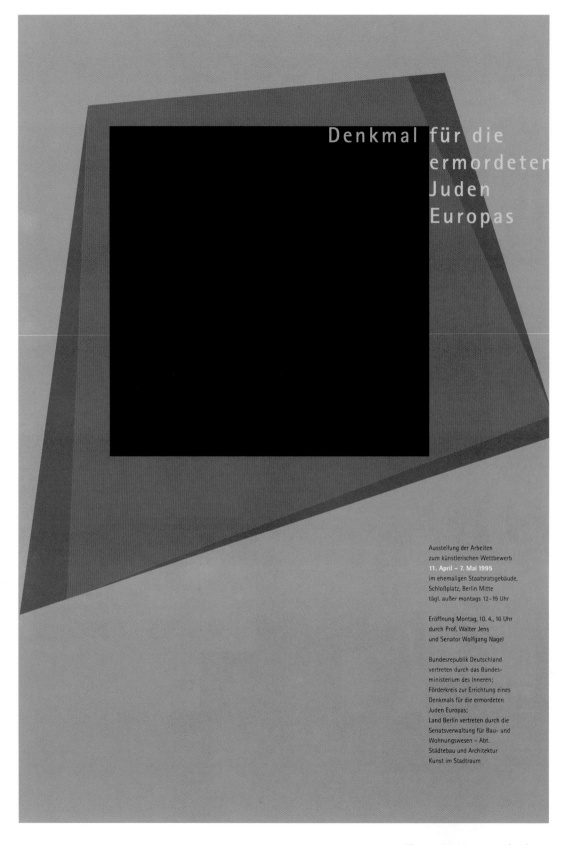

Denkmal für die
ermordeten
Juden
Europas

Ausstellung der Arbeiten
zum künstlerischen Wettbewerb
11. April – 7. Mai 1995
im ehemaligen Staatsratsgebäude,
Schloßplatz, Berlin Mitte
tägl. außer montags 12–19 Uhr

Eröffnung Montag, 10. 4., 16 Uhr
durch Prof. Walter Jens
und Senator Wolfgang Nagel

Bundesrepublik Deutschland
vertreten durch das Bundes-
ministerium des Inneren;
Förderkreis zur Errichtung eines
Denkmals für die ermordeten
Juden Europas;
Land Berlin vertreten durch die
Senatsverwaltung für Bau- und
Wohnungswesen – Abt.
Städtebau und Architektur
Kunst im Stadtraum

These posters were created to draw
public attention to various exhibits
and monuments relating to crimes
against humanity committed during
the Nazi era.

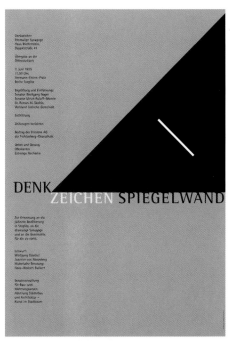

The design for the logo of the
National Gardening Exhibition 2001
in Potsdam focuses on the concept
of a decentralized exhibition.

potsdam
bundes gartenschau
2001

ANNA B. DESIGN

PRINCIPAL: Anna Berkenbusch
FOUNDED: 1989

Erkelenzdamm 11-13
10999 Berlin
TEL: (49) 30 69 48 38 1
FAX: (49) 30 69 22 59 6
EMAIL: annaB@03.net

Bold typography and provocative photography make Anna Berkenbusch's film posters instantly recognizable and often unforgettable. After a stint with MetaDesign in Berlin and London in the late 1970s and early 1980s, Anna Berkenbusch and two partners established Denk Neu! GmbH, Berlin in 1982, a firm noted for its graphic design work for important social causes. Seven years later she went off on her own, to concentrate on film poster design for both huge, commercial films and small, independent pictures. She commutes regularly to Essen where she teaches typography at the Universitat Gesamthochschule Essen.

Her sense of the role of a designer helps explain the originality and complexity of her own work. "A designer first must be able to think," she says. But then the designer must "also be a little crazy, dream, ask the right questions, turn things upside down and try to master language." As for design education, Berkenbusch believes that it "should form a foundation, a pool from which the designer can draw; these resources must be both complex and open like an immaterial armament for students' future lives as designers."

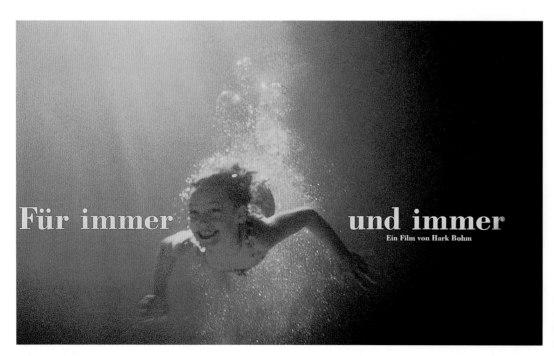

Using simple visual imagery, this poster conveys the essence of the film about a young girl who is adopted.

Die hundert
besten Plakate
des Jahres 1995
Ausstellung
in der Berliner
Stadtbibliothek
Breite Straße 32-34
10178 Berlin
24 Mai bis
29 Juni 1996
Breite Straße 32-34
Berlin-Mitte
Montag
14 bis 21 Uhr
Dienstag bis Freitag
9 bis 21 Uhr
Samstag
9 bis 16 Uhr
Veranstalter:
Allianz deutscher
Designer
(AGD)
Bund Deutscher
Grafik-Designer
(BDG)
Verband der
Grafik-Designer
(VGD)

Die 100 besten Plakate des Jahres 1995

Ausstellung

Berliner Stadtbibliothek

A poster about posters, this design
was for *The 100 Best Posters of 1995*
sponsored by Verband der Grafik-
Designer e. V. Berlin, 1996. In addi-
tion to the poster, Anna B. also
designed the catalogue cover and
invitation card for the exhibition.

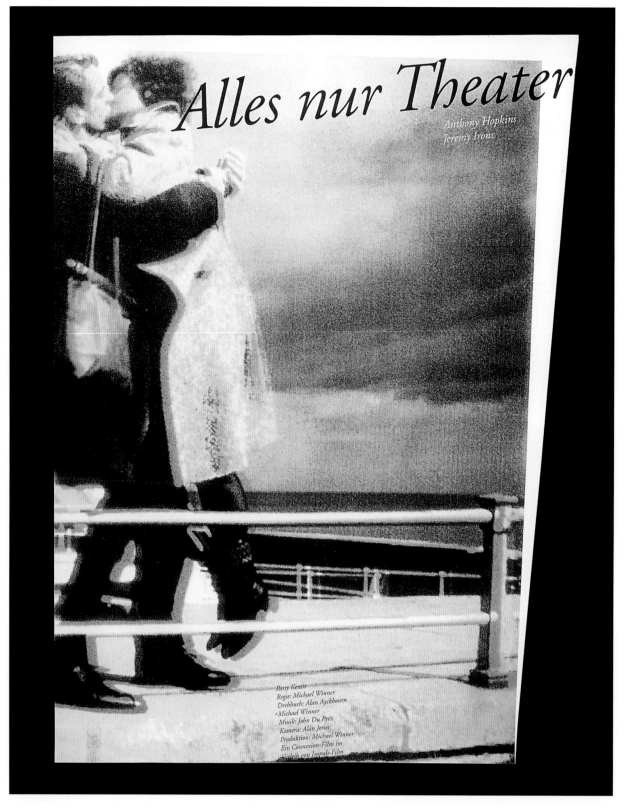

Alles nur Theater

Anthony Hopkins
Jeremy Irons

Patsy Kensit
Regie: Michael Winner
Drehbuch: Alan Ayckbourn
»Michael Winner
Musik: John Du Prez
Kamera: Alan Jones
Produktion: Michael Winner
Ein Connexion-Film im
Verleih von Impuls-Film

The sepia quality of this film poster
conveys a sense of mystery and
romance. Designed by Anna B. and
Katrin Schek, it is for a low-budget
movie about a small English
provincial theatre.

Yasemin
VON HARK BOHM

Anna Berkenbusch has written that "typography cannot be seen in isolation," there must be a "feeling for form and contrast, for composition, for surface and space and... the ability to deal with content and images and their manipulation...." These two film posters illustrate her mastery of these principles to create great dramatic effect.

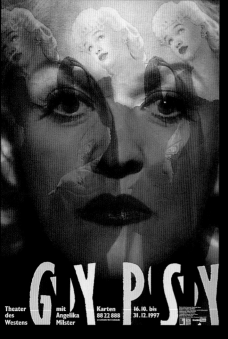

GYPSY

Theater des Westens · mit Angelika Milster · Karten 88 22 888 · 16.10. bis 31.12.1997

These posters for the musicals *Gypsy* and *Dream Girls* and for the movie *Lola* were designed by Anna B. and Katrin Schek.

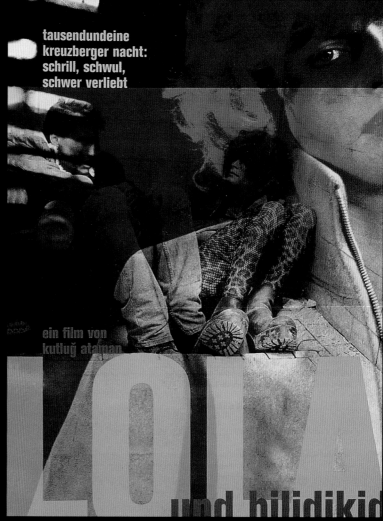

tausendundeine kreuzberger nacht:
schrill, schwul,
schwer verliebt

ein film von
kutluğ ataman

LOLA und bilidikid

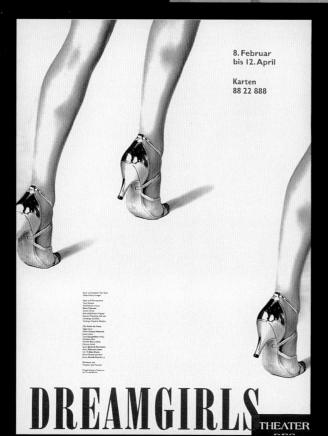

8. Februar
bis 12. April

Karten
88 22 888

DREAMGIRLS

THEATER
DES

DAS UR! TEIL IST EIN TEIL DER

UHR

JEDOCH EIN KLEINES TEIL chen UR

VER GANGenheiT IS ZIE R

EINE ?

DOCH WEITER

! KOmmT MAN OHNE

IHR!

These film posters rely exclusively on
the masterful placement of type by
this award winning typographer.
They are for a documentary film
about the German artist Kurt
Schwitters, who made extensive use
of typography in his collages.

PRINCIPALS: Birgit Tümmers, Claudia Trauer,
Nauka Kirschner, Petra Reisdorf
FOUNDED: 1993

Lehrter Strasse 57
10557 Berlin
TEL: (49) 30 39 44 00 4
FAX: (49) 30 39 44 00 3
EMAIL: atelier@doppelpunkt.com
WEB: www.doppelpunkt-berlin.de

ATELIER : [DOPPELPUNKT]

The interplay of language with typography is the stylistic foundation of the work of atelier :
[doppelpunkt]. Understanding the firm's name provides insight into its work, work that
embodies typographic precision, often with a sense of humor, with layers of meaning. The studio
was founded in 1985 by Betina Müller as atelier : müller. When Müller left the firm in 1993, the
remaining partners settled on atelier : [doppelpunkt]. "Doppelpunkt" is the German word for the
punctuation mark "colon", "the punctuation mark that had accompanied us from the start."

The partners insist that content dictate design rather than being subservient to it. This allows the
design to evolve over time yet retain its original corporate look, as has happened with the firm's
10 years of poster designs for the Musik Biennale Berlin. When they were asked to create a poster
design for the Musik Biennale, they chose a black and white theme with bars reminiscent of
sheets of music and representing music conceptually. The posters are in stark contrast to the
many colorful film posters for the Berlin film festival that is held at the same time.

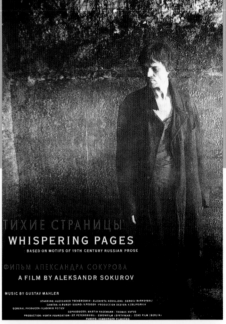

These posters are for the films
Mother and Son, *Whispering Pages*
and *Moloch* all by the Russian
director Aleksandr Sokurov. The
melancholy nature of these films is
apparent in the designer's restrained
use of imagery and type.

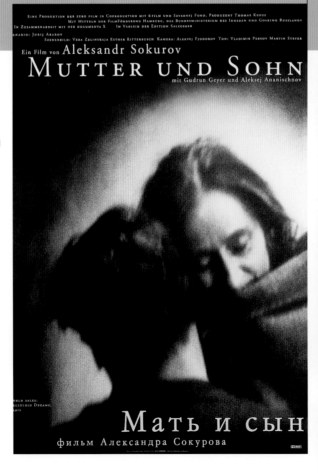

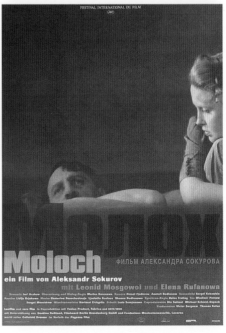

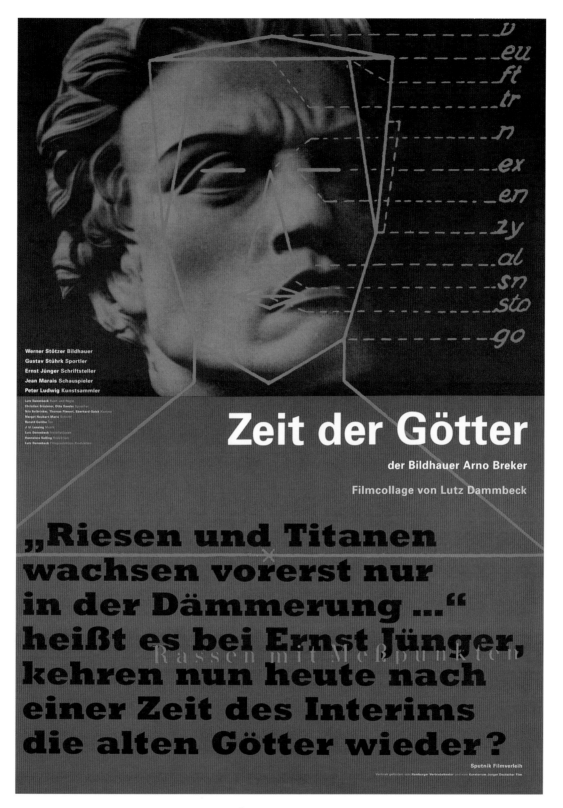

This poster was created for the documentary film by Lutz Dammbeck about Hitler's favorite sculptor Arno Breker.

For several years the designers have been commissioned to create posters for the annual event *Sommernach der Lyrik* (*Summer's Night of Lyrics*). While the corporate look for the series was established in the beginning, the skillful manipulation of type results in a fresh and distinctive poster each year.

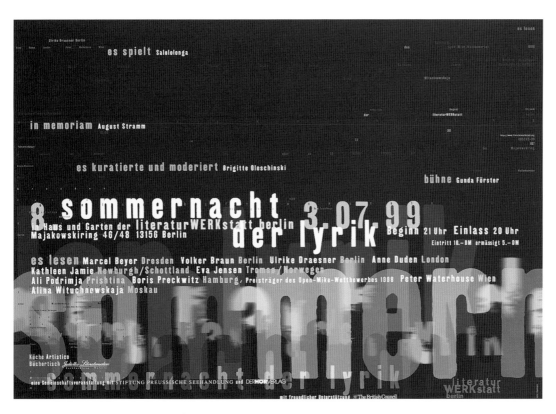

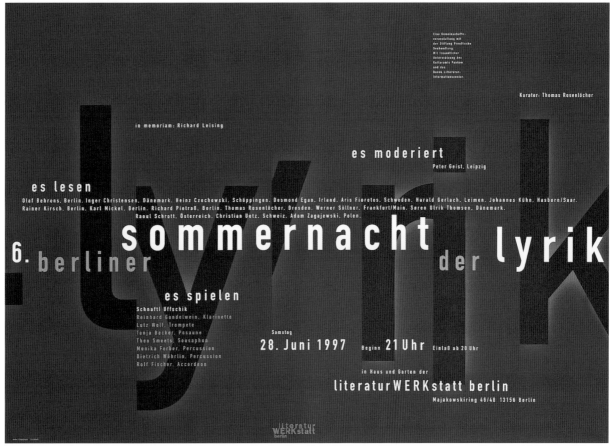

Above is a poster announcing an exhibition at the Deutsches Historisches Museum about famous Jews who emigrated from Austria during the Nazi occupation. At right are posters for the Berlin design museum Bauhaus Archiv including one announcing an exhibition of the graphic work of atelier : [doppelpunkt].

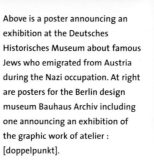

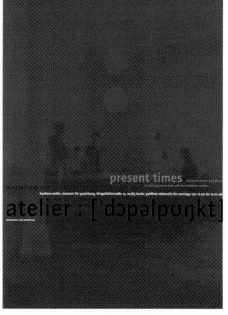

An important staple of the firm's
work is creating designs for
audio books for the publisher
Der Audio Verlag.

Literature Express Europe 2000 is a
book that atelier : [doppelpunkt]
created about a train travel project.
Writers from all over Europe
contributed to the project.

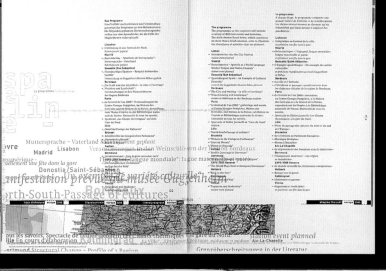

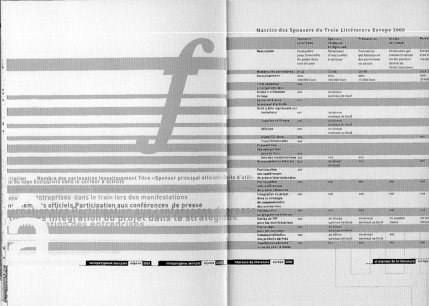

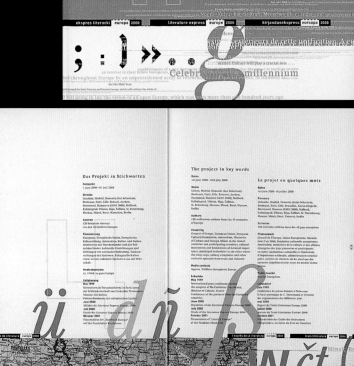

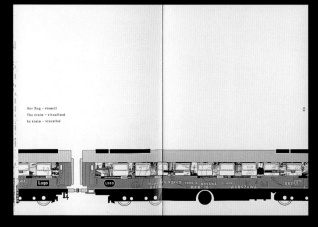

Max-Planck-Institut für Wissenschaftsgeschichte

Max Planck Institute for the History of Science, Berlin

25 – 28 | June 1998

Ken Alder, Francesca M. Bordogna, Joan Cadden, John Carson, Simona Cerutti,
Roger Chartier, Lorraine Daston, Arnold Davidson, Brigid Doherty, Barbara Duden,
Rivka Feldhay, Peter Galison, Carlo Ginzburg, Ian Hacking, Glenn Most, Donald MacKenzie,
Ian Maclean, Harry Marks, Krzysztof Pomian, Emmanuela Scribano, David Wellbery

Demonstration Test Proof

For information, contact

Tilman Sauer, Conference on HGR
Max Planck Institute for the History of Science
Wilhelmstraße 44, 10117 Berlin, Germany
Telephone (+4930) 22 667-115/102
Fax (+4930) 22 667-299
e-mail: mpifw@mpib-berlin.mpg.d400.de

The conference

will provide a forum for historians,
philosophers and physicists
to meet and discuss recent work
in the history of General Relativity:

Program

- Formalism and Heuristics in its Genesis
- The Realm of Alternatives in its History
- Experimental and Theoretical Explorations
- National Contexts and its Vicissitudes
- Historical and Philosophical Contexts
- Historical-Critical Studies of its Concepts
- The Problem of Model Building in Cosmology

4th
International Conference
on the History of General Relativity

Berlin, July 31 – August 3, 1998

hosted by

the Max Planck Institute
for the History of Science

Organizing Committee

Julian Barbour, South Newington
Silvio Bergia, Bologna
Jürgen Ehlers, Potsdam
Jean Eisenstaedt, Paris
Hubert Goenner, Göttingen
József Illy, Budapest
Michel Janssen, Pittsburgh
A. J. Kox, Boston/Amsterdam
John Norton, Pittsburgh
Jürgen Renn, Berlin
Jim Ritter, Paris/Berlin
Jose M. Sánchez-Ron, Madrid
Tilman Sauer, Berlin
John Stachel, Boston/Berlin
Andrzej Trautman, Warsaw
Vladimir Vizgin, Moscow

A complete corporate design
campaign was created for the Max
Planck Institute for the History of
Science. In creating posters for the
Institute, the designers interwove
historical images and text into a
decidedly contemporary design.

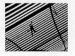

The design for this book uses the
subject matter—architecture—to
create a dramatic cover.

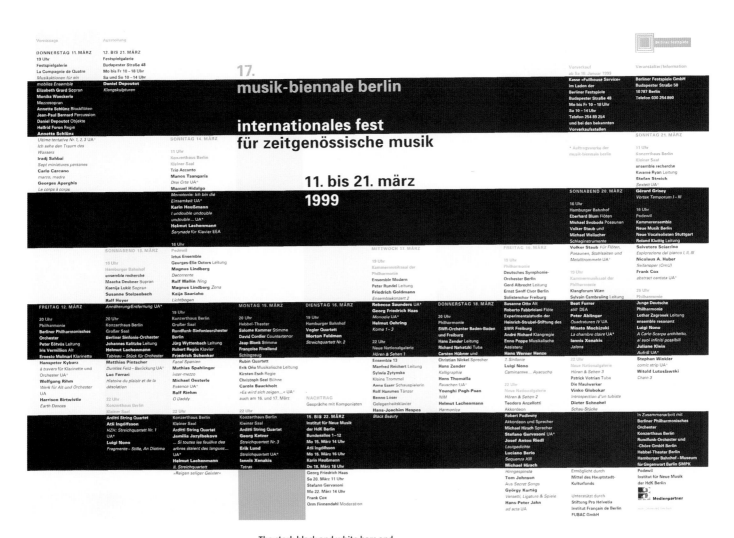

The stark black and white bars and orthogonal quality of this annual poster for the Musik-Biennale Berlin distinguish this event from the film festival (with its colorful and image-driven posters) that is held at the same time.

BAUER + MÖHRING

PRINCIPALS: Vera Bauer, Anja Möhring
FOUNDED: 1999

Schmargendorfer Strasse 25
12159 Berlin
TEL: (49) 30 85 96 48 33
FAX: (49) 30 85 96 48 34
EMAIL: verabauer@snafu.de

Most graphic designers in Berlin receive their formal training at the Hochschule der Künste Berlin and Vera Bauer and Anja Möhring are no exception. Bauer began her design career as a book designer and since the two partners established their firm in 1999 book cover design has become a specialty. While their cover designs encompass the entire range of book publishing from fiction to non-fiction, including business titles, it is their designs for a series of 60 crime novels for Ullstein Publishing Company that quickly catch the eye.

The challenge of creating a standard look for the series while giving each book its own identity has been deftly handled using bits of evidence and clues from each story along with bold graphics while maintaining the gritty look one expects from such pulp fiction. Bauer + Möhring are equally skilled at using simple stock photography to create covers that convey the idea of the book without giving away the plot.

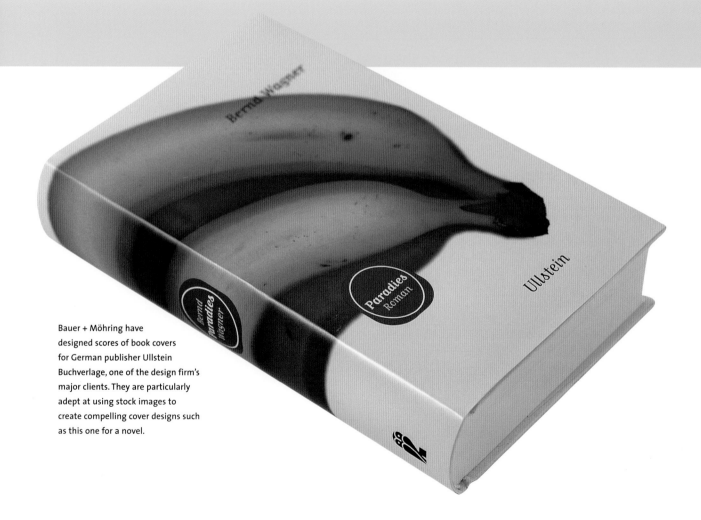

Bauer + Möhring have designed scores of book covers for German publisher Ullstein Buchverlage, one of the design firm's major clients. They are particularly adept at using stock images to create compelling cover designs such as this one for a novel.

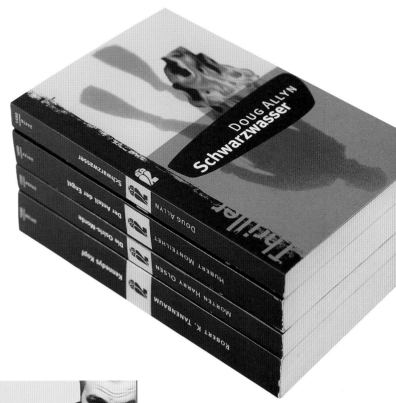

ELISE TITLE
Todsünden

GEOFFREY HOMES
Schrott

ZACHARY KLEIN
Die Lebenden und
die Toten

These examples of a series of
approximately 60 paperback mysteries
illustrate the designers', ability to create
distinctive covers while retaining the
series look.

JÜRGEN EBERTOWSKI
Berlin Oranienplatz

STUART KAMINSKY
**Liebermans
Juwel**

JAMES ELLROY
**Ein amerikanischer
Thriller**

Jane Holland
Die Billardspielerin
Roman

ULLSTEIN

John Fowles
Der Sammler
Roman

ULLSTEIN

Jean-Marie Gourio
Die Bibliothekarin
Roman

ULLSTEIN

Ekstase, Rausch und obsessionen
Ein Lesebuch der Leidenschaften
von Linda Walz und Gerhard Seidl

ULLSTEIN

Luke Rhinehart
Der Würfler
Roman

ULLSTEIN

These are design concepts for a
special edition of romance
paperbacks using photography by
Tobias Schneider.

Colin Thubron
Die Trapezkünstlerin
Roman

ULLSTEIN

These book jackets for a variety of novels skillfully reveal the essence of the books' content while avoiding being too literal.

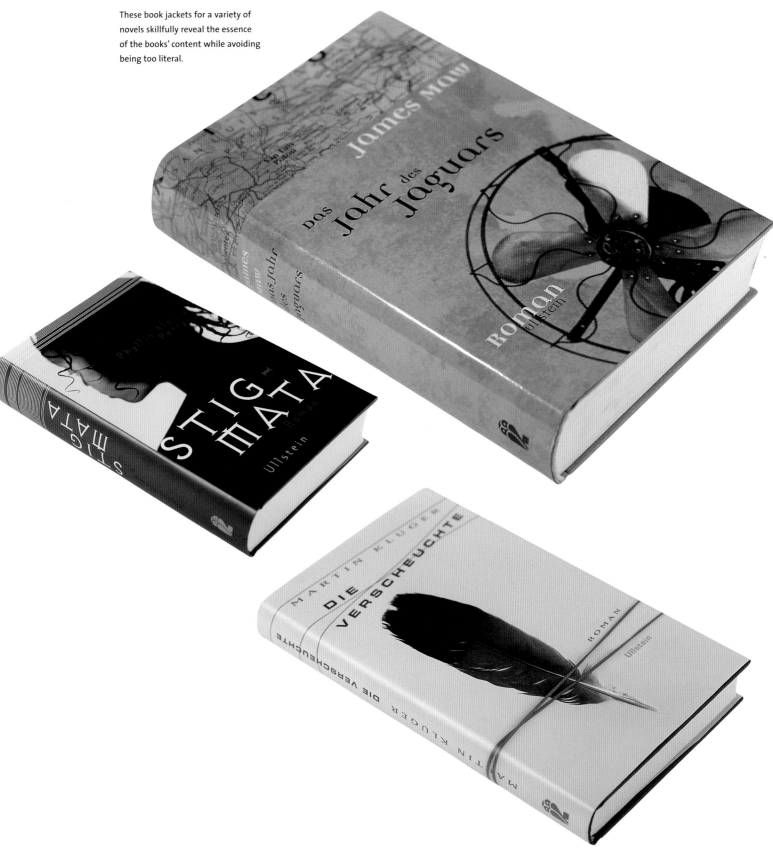

CYAN

PRINCIPALS: Daniela Haufe, Detlef Fiedler
FOUNDED: 1992

Rosenthaler Strasse 13
10119 Berlin
TEL: (49) 30 28 33 00 4
FAX: (49) 30 28 32 86 9
EMAIL: cyan@cyan.de
WEB: www.cyan.de

The pedigree of cyan is indisputable: Detlef Fiedler is a founder of the renowned East Berlin graphic design firm, grappa. Daniela Haufe joined grappa two years later. In 1992, they founded cyan, and work primarily for arts and culture organizations. Haufe and Fiedler are extremely selective when choosing their clients, preferring projects they find artistically interesting rather than financially rewarding. In fact, many of their clients have design budgets that are so limited they have developed an esthetic that relies on work that is often printed in two colors on low-grade paper stock. "We attempt to melt text, images, and paper into a unified entity," they note in the manifesto which they have written on their design philosophy. In the end, cyan's work is as much about art as it is graphic design.

Having practiced in East Berlin long before the wall came down, they were accustomed to designing without the aid of computers, so it is only in the last few years that they have succumbed to the lure of technology. "At first, we were not particularly fascinated by the possibilities of electronic technology. This may have been due to the reference to the early 20th century avant-garde tradition which unites us," according to Haufe. However they have embraced the computer in their work, declaring that "by way of the computer, graphic design has become more democratic. Graphic design is no luxury pet for a lucky few any more."

Much of Cyan's work is with nonprofit organizations including the Hoergalerie in Parochial (the Parochial Church) which was destroyed during World War II. The ruins have been preserved and a number of cultural events are held there. Using three colors, Cyan created this op-art poster for an event in 1999.

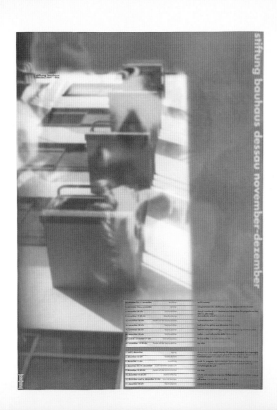

The Bauhaus was founded in 1919 in Weimar, Germany, by Walter Gropius. In 1926, Gropius built a new building for the school in Dessau. A foundation was created in 1976 that oversees a museum and organizes events, lectures, theatre performances, and concerts at the school. For several years, Cyan has designed program posters such as these, which consist of collages of photographs. Early on, they used historical Bauhaus photographs but now they rely mostly on their own.

Freunde Guter Musik is a foundation that organizes modern music concerns and other special music events. According to Cyan, "They do it with a lot of humor." As a result, for this poster, "We have designed a living room with TV, goldfishes, cooking machine, and a woman who's cleaning...and we hope it is funny."

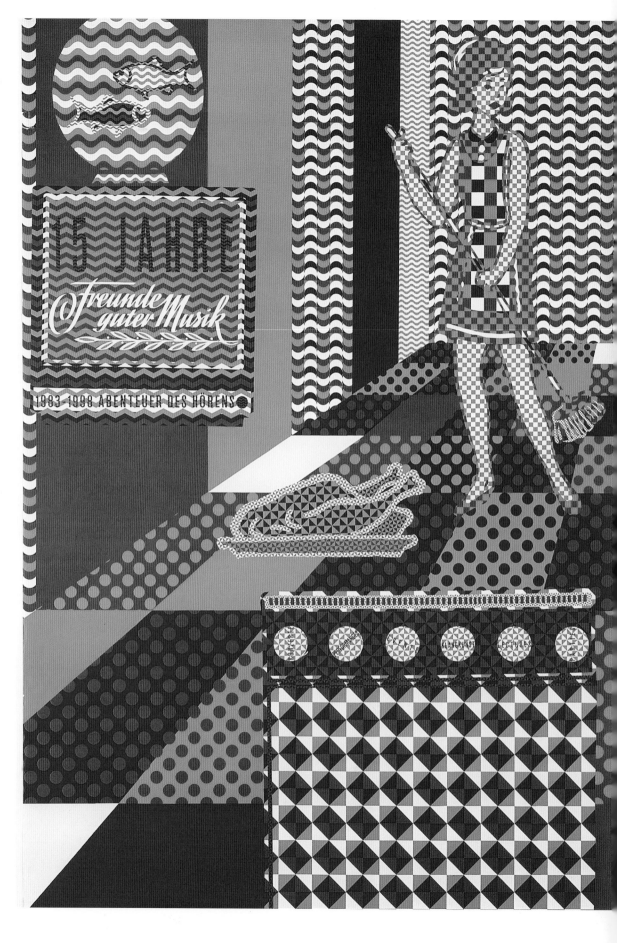

This poster was created for five sound exhibitions in the ruins of the Parochial Church, which has a sound art gallery. Bold, abstract color schemes are integral to many of Cyan's designs, no more so than in this minimalist composition.

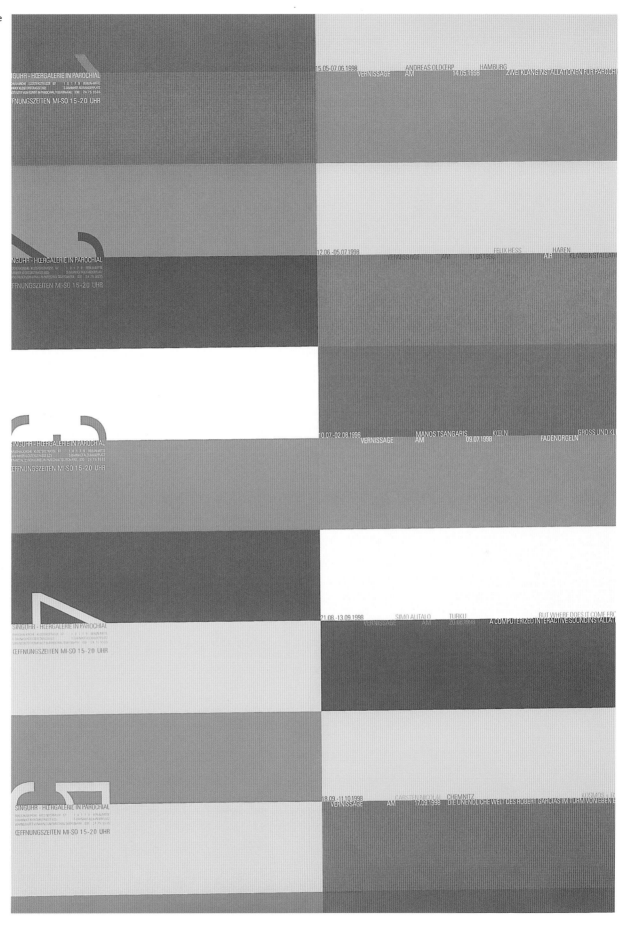

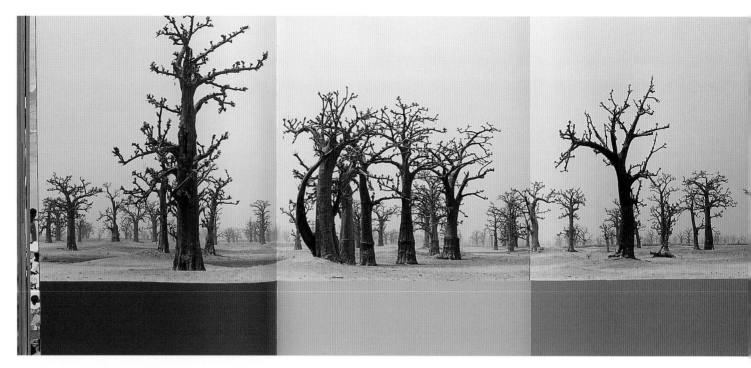

Turkish photographer Cem Akkan
asked cyan to design a book using
his photographs shot in Africa.
To prepare for this project, Daniela
and Detlef traveled in Africa for
four weeks. When they returned,
"We tried to put the light and
the colors of the continent into
this book."

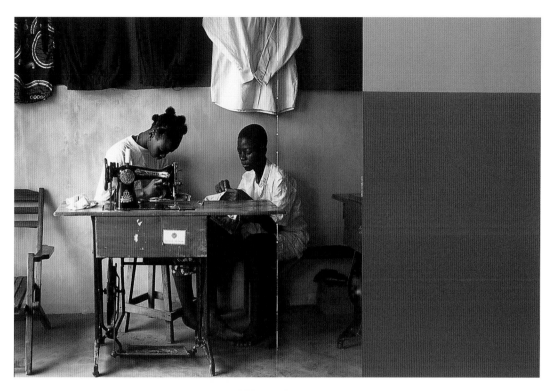

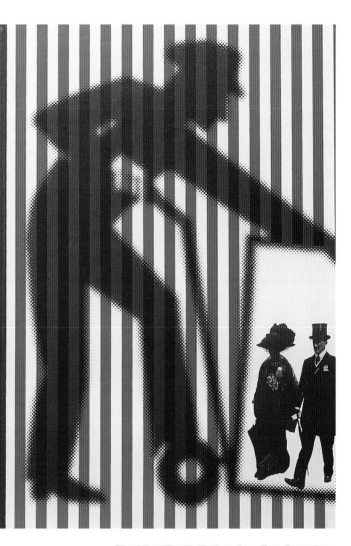

Having reread *The Communist Manifesto* by Marx and Engels in 1994, Danilea and Detlef decided to publish a special issue of the document themselves. Printed on low-grade paper stock, this booklet has a freshness and urgency that characterizes much of Cyan's work.

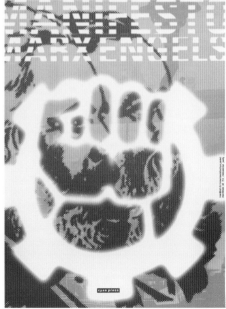

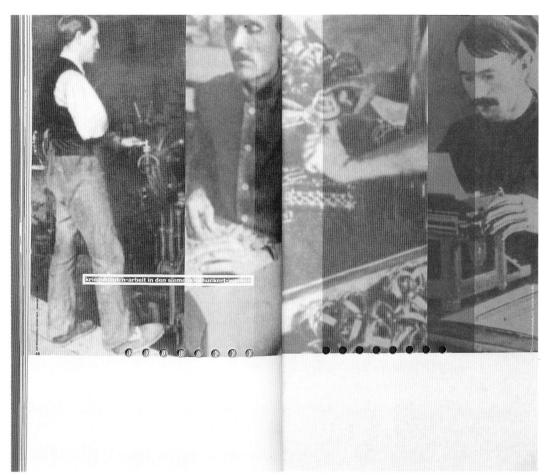

Forum + Zweck is a design magazine that was founded in the 1960s. Cyan was asked to redesign it several years ago. Each issue of the magazine has a special theme. Issue 11/12, shown here, was on repairing things, so the issue came with several rivets that are to be used by the reader to bind the magazine.

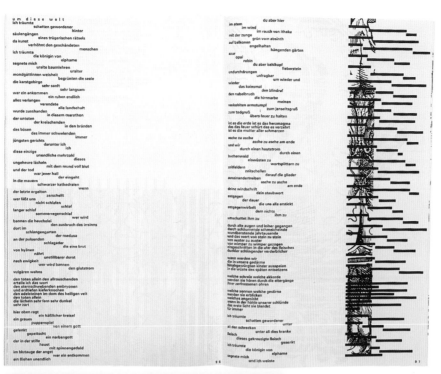

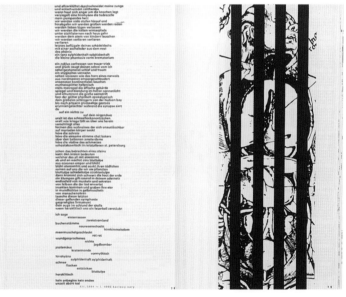

The founders of cyan have worked with the young German poet and musician Scardanelli for a number of years. Most of his poems have themes relating to death and illness (he worked in hospitals at one time). In designing this book, *Hautabziehn*, cyan used illustrations found in psychiatric books published over the last two centuries.

This catalogue was designed for an exhibition at the Bauhaus of the work of some architecture students. Cyan used the students' drawings to create collages. The exhibition's theme was warehouses of the future. The catalogue was printed in two colors on low-grade paper stock.

PRINCIPALS: Thomas Bauer, Max Moennich
FOUNDED: 1993

Kastanienalle 10
10435 Berlin
TEL: (49) 30 44 91 64 1
FAX: (49) 30 44 34 17 20
EMAIL: deblik@snafu.de
WEB: www.deblik.de

DE'BLIK

"Steady as she goes," might best describe the work of de'blik. Founded in 1993 by Thomas Bauer, Max Moennich and Wim Westerveld (who left in 1997 and is now a principal of fernkopie), the firm specializes in book design, typography and visual concepts for science. Their client base consists mainly of scientific publishers such as Bertelsmann Springer, Springer New York, Sage London and DAV. Since most of their work involves creating a series look for textbooks in medicine and management, their cover designs are restrained, with subtle visual cues that alert the reader to the specific contents of a book in the series. So conservative are their designs that they proudly declare their membership in the Ring Conservativer Gestalter (the Circle of Conservative Designers) and have produced a number of invitations and member cards for the organization. Restrained, quiet graphic design has its rewards. Their beautifully designed *Berlin-Tokyo* book won the prestigious German Book Design Award in 1997.

The careful and thoughtful integration of Japanese and German text in *Berlin-Tokyo* exemplifies de'blik's refined approach to graphic design. The black and white photographs and illustrations are used in such a way as to not detract from the overall tranquility of the design. The restrained use of black and white illustrations and photographs enhances the refined nature of this book which won the German Book Design Award.

HEINRICH SCHICKHARDT

Baumeister der Renaissance
Leben und Werk des Architekten, Ingenieurs und Städteplaners

SÖNKE LORENZ
WILFRIED SETZLER
(HG./ED.)

Maître d'oeuvre de la Renaissance
Vie et oeuvre d'un architecte, ingénieur et urbaniste

DRW

Design for the monograph on the work of the Renaissance architect Heinrich Schickhardt was completed in 1999. Although printed in four-color, it still reflects the restrained work of de'blik.

Cover designs for a series of
management books published by
Springer. Subtle imagery is used to
distinguish individual titles within
the series.

Subtle humor is evident in these invitations and membership cards designed for the RCG.

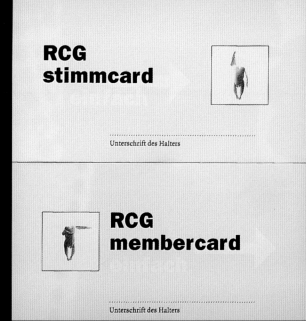

DIE GESTALTEN VERLAG

PRINCIPALS: Robert Klanten
FOUNDED: 1995

Zehdenicker Strasse 21
10119 Berlin
TEL: (49) 30 44 91 27 2
FAX: (49) 30 30 87 10 68
EMAIL: verlag@die-gestalten.de
WEB: www: die-gestalten.de

"We never pass on any information about principals, clients, philosophy, etc. Maybe this is our philosophy," declares Robert Klanten, the president of Die Gestalten, the hip Berlin publisher of books about design, art, graphic design, photography, new media, music, theory, culture, and "strange things," as Die Gestalten notes on its website. The language barrier is not a problem with books published by the company since they are virtually all image-based, with cutting-edge design featuring stunning and provocative off-the-wall subject matter. Recent titles have included *Space Manual*, a guide to surviving the wilds of outer space; *Spark*, a collection of the work of the influential European graphic designer, Dirk Rudolph; *Trigger*, a compilation of cutting-edge graphic design; and *Radical Eye*, the haunting photography of Miron Zownir.

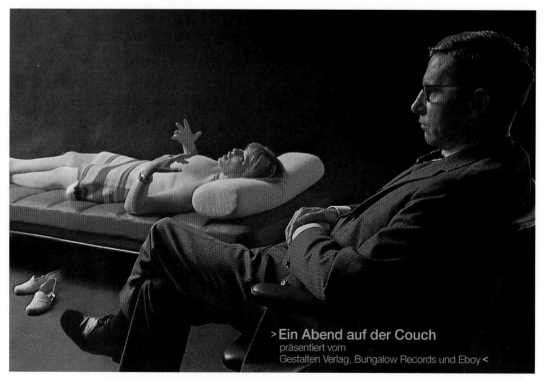

A patient on the psychiatrist's couch is an apt image for this invitation to a presentation by Die Gestalten. It also reflects the in-your-face graphic style of many of the company's books and graphic designs.

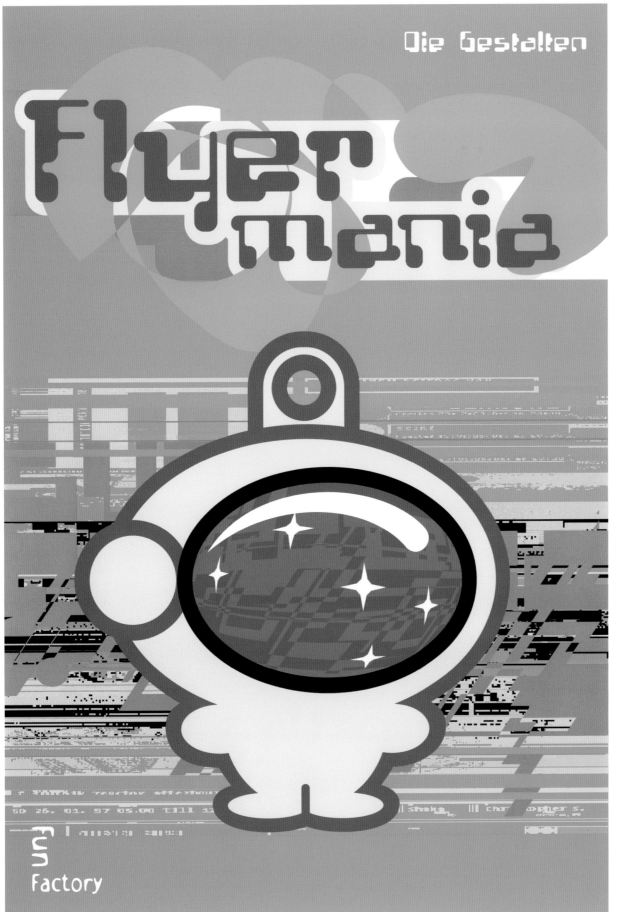

Flyer mania

Fun Factory

Flyer Mania is a collection of the best club and party flyers by cutting-edge graphic designers. It works as both a contemporary reference tool and as a witty documentation of today's techno and house party scene. Many of the books published by DGV showcase such trendy graphic design.

Die Gestalten's aggressive design
sensibilities are revealed in this
series of advertisements for a
fashion company.

FOTO / INFORMATIONSRECHERCHE, -BESCHAFFUNG UND -ORGANISATION

WISSENSCHAFT / INFORMATIONSRECHERCHE, -BESCHAFFUNG UND -ORGANISATION

Subtle colors and imagery
distinguish this corporate image
campaign.

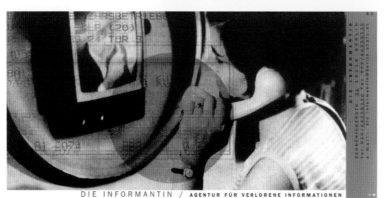

DIE INFORMANTIN / AGENTUR FÜR VERLORENE INFORMATIONEN

DIE INFORMANTIN
Agentur für verlorene Informationen

HERBSTGRÜSSE

L

WETTERSCHUTZ Bei Pannen, Freizeit und Hobby

DIE INFORMANTIN
Tania Velten & Annette Brunner
ZEHDENICKERSTR. 21 D-10119 Berlin
Tel. 030/44 35 83 30 e-mail: die.informantin@berlin.snafu.de

A logo designed by the studio
symbolizing "information".

doozer

This cover design for a jazz album recalls the sophisticated music scene of an earlier time.

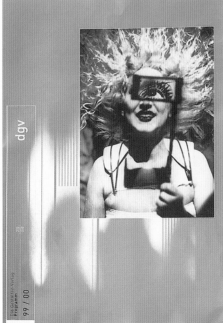

This catalogue featuring recent book titles from Die Gestalten is printed using metallic ink on a glossy paper stock. The spread illustrates the book Busy featuring the work of popular painter Jim Avignon and Design Agent km7—*License to Design* showcasing the graphic design of km7.

PRINCIPALS: Tim Brauns,
Hendrik Gackstatter, Fax Quintus
FOUNDED: 1993

Lützowufer 12
10785 Berlin
TEL: (49) 30 26 48 02 70
FAX: (49) 30 26 48 02 71
EMAIL: contact@e27.com
WEB: www.e27.com

E27

The three young founders of e27 declare that they are interested in "clever function and simple solutions" to design problems. They got the name of their firm-, e27, from the German rating system for light bulbs similar to the wattage rating system in the United States. Osram, a lighting manufacturer in Germany, used an advertising slogan that first attracted them: "Always good light with e27."

The principals work in different design fields so the firm's work is wide-ranging, from product development to navigational systems for websites to corporate identity. They arrive at their design solutions through a participatory process with the clients. When creating the identity program for Waldkrankenhaus Gransee, a hospital located in a forest, e27 involved 200 nurses in designing a suitable graphic identity scheme for the hospital—which turned out to be a green deer that appears on everything from flags to china.

The designers used the copyright symbol as the basis for creating a corporate image campaign for a photographic studio. Just as the symbol signifies a unique work, so too are the photographers' images unique.

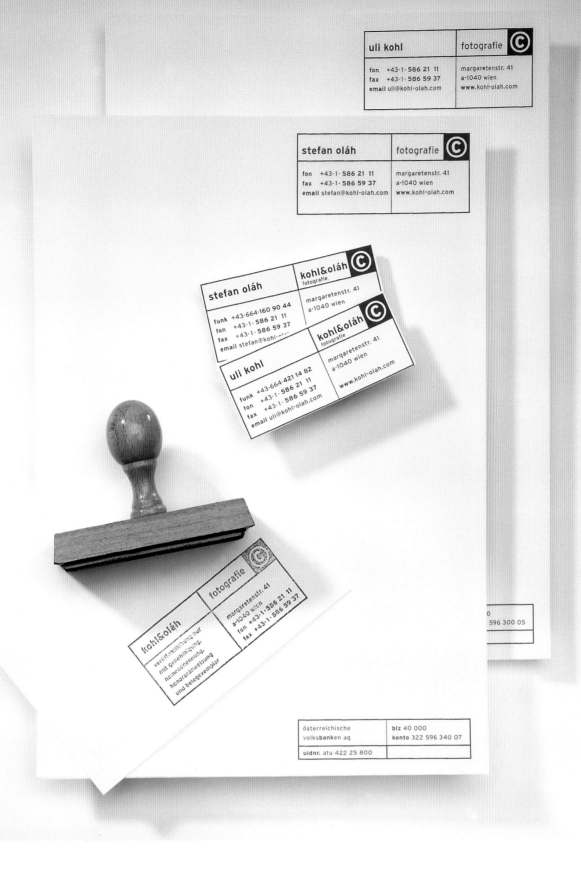

uli kohl | **fotografie** ©

fon +43·1· 586 21 11
fax +43·1· 586 59 37
email uli@kohl-olah.com

margaretenstr. 41
a-1040 wien
www.kohl-olah.com

stefan oláh | **fotografie** ©

fon +43·1· 586 21 11
fax +43·1· 586 59 37
email stefan@kohl-olah.com

margaretenstr. 41
a-1040 wien
www.kohl-olah.com

stefan oláh | **kohl&oláh** fotografie. ©

funk +43·664·160 90 44
fon +43·1· 586 21 11
fax +43·1· 586 59 37
email stefan@kohl-ol...

margaretenstr. 41
a-1040 wien

uli kohl | **kohl&oláh** fotografie ©

funk +43·664·421 14 82
fon +43·1· 586 21 11
fax +43·1· 586 59 37
email uli@kohl-olah.com

margaretenstr. 41
a-1040 wien

www.kohl-olah.com

kohl&oláh | **fotografie** ©

veröffentlichung nur
mit genehmigung,
namensnennung,
honorarüberweisung
und belegexemplar

margaretenstr. 41
a-1040 wien
fon +43·1·586 21 11
fax +43·1·586 59 37

596 300 05

österreichische
volksbanken ag

blz 40 000
konto 322 596 340 07

uidnr. atu 422 25 800

Letterhead design for a consulting firm (left) and and accounting firm (right). Because tax consultants in Germany are not allowed to advertise, a design solution was required that would be graphically recognizable without the use of a logo.

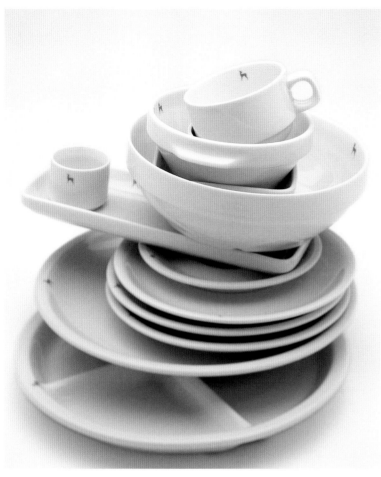

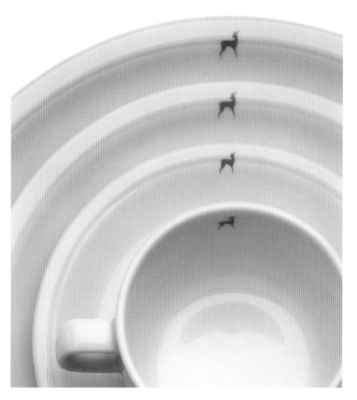

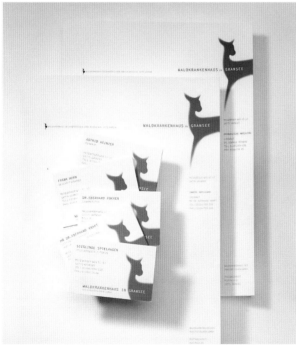

A green deer was chosen as the symbol for a hospital located in a forest. The designers use the stylized animal on everything from signage to stationary to the plates and cups used to serve meals to the patients and staff.

PRINCIPALS: Steffen Sauerteig,
Svend Smital, Kai Vermehr (Berlin),
Peter Stemmler (New York)
FOUNDED: 1997

Kastanienallee 10
10435 Berlin
TEL: (49) 30 44 00 87 15
FAX: (49) 30 44 00 87 16
EMAIL: eboy@eboy.com
WEB: www.eboy.com

EBOY

eboy has its roots firmly planted in the Internet where the partners first began their collaboration while playing games with each other on the web. Their design philosophy is simple: "stay small and highly motivated like a guerrilla group. Use the incredible possibilities of the web to accept hot in/out projects all over the world."

Pop culture has had a strong influence on their work, as have video games, comics, street typography, and other forms of mass culture. Their work is heavily focused on screen design for software, websites, and online games. In New York, partner Peter Stemmler creates digital illustrations for such diverse magazines as *Wired*, *SPIN*, *Playboy* and *The New Yorker*. eboy also specializes in font design and has created PEECOL, an ingenious system for creating screen images using repetitive picture "bricks". They discovered that areas of pictures are often repetitive, and single parts can be reused at different places in a picture being created on the screen. PEECOL is accessible on their website where visitors are encouraged to create their own PEECOL images.

Illustrations for *Wired* magazine.

FFSUBMONO

-Med
-Fat
-Dry con
-Med con
-Fat con

DryFrom(12)Pözty+:tr
Ykommunikà@CROOK...91$
äö•'ntyGM™©—45.094€¥
UpperTURNäff_COCA@ROLL»∫3
l§9=12www.eboy.COOLcash/?
Zmox&WORRY_äft±2.410™ra

FFSUBVARIO

-Dry
-Med
-Fat
-Dry con
-Med con
-Fat con

WOMY'nt{234}evil;packtl
aquire~[flight]¬HACKwimx*
#72"dpi∞ROBOxofkem;%ät
TerrorZcary=55¢"'∫garbageOP!
POPULARΩ53/l\◊69€tyson≈№Mp
surfsoup{2}#WOW!;:*loftÜmø

INCLUDING HOT BONUS FONT »FF SCREENLOGGER«
COOL/COOLbaCK/HOT
Cool CoolBack Hot

FFeboy

FF eboy REG alpha OPTIMIZED FOR 8 Pt. at 72 dpi
eboy_REG-0806@8Pt.crocodile*Attacker
FF eboy REG beta OPTIMIZED FOR 12 Pt. at 72 dpi
QUEER=QUEEN#REG-1209@12
FF eboy REG gamma OPTIMIZED FOR 16 Pt. at 72 dpi
1612@16Pt.200%OPENeds
FF eboy TNT alpha OPTIMIZED FOR 8 Pt. at 72 dpi
eboy_TNT-0806-DANGER%"851
FF eboy TNT beta OPTIMIZED FOR 12 Pt. at 72 dpi
COMICS@1209TNT"»5.987005
FF eboy TNT gamma OPTIMIZED FOR 16 Pt. at 72 dpi
MBOY!*TNT1612-+LOWtECH
FF eboy XTD alpha OPTIMIZED FOR 8 Pt. at 72 dpi
Rude*zooming@0806&QUAKE?
FF eboy XTD beta OPTIMIZED FOR 12 Pt. at 72 dpi
1209°^iXTD@OPENdtF
FF eboy XTD gamma OPTIMIZED FOR 16 Pt. at 72 dpi
OFFIN™XTD1612!

INCLUDING HOT BONUS FONT »FF XCREEN«
Straight/LINEX/DOUBLEX
Straight Linex Doublex

Examples of fonts created by eboy. The font card on the left is FF-Sub; above is FF-eboy; and bottom is FF-Typestar. All were created for FSI Fontshop International, Germany.

FF Typestar™ Normal *Italic* **Black** ***Italic*** Ocr
hard disc drive | lecteur de disque dur (N°3)
Festplattenlaufwerk | unidad del disco duro
read/write head, tête de lecture/écriture
Schreib-/Lesekopf, cabeza de lectura\escritura
(#43.445.87,−) mouse+souris+Maus+ratón
connection cable [...] câble de raccordement
Verbindungskabel cable de conexión ¡¿ ?!
{5} keyboard | clavier | Tastatur | teclado***
@ command key @ touche de commande @ ⌐
Befehlstaste @ tecla de mando *(6) mini-floppy*
disc | discquette rigide | Mini-diskette | disco
flexible pequeño »£¥« access window • fenêt-
re de lecture • Zugriffsöffnung • ventana de
acceso (1998) look@http://www.fontfont.de
(73.00_21,−) videomonitor / écran
l Bildschirmeinheit l monitor del
vídeo l brightness control (‚‚@")
réglage de la luminosité, Hellig-
keitsregler ▪ control de brillo ▪
CONFIGURATION OF AN OFFICE (!)
AUTOMATION SYSTEM ▪ CONFIGURATION
D'UN SYSTÈME BUREAUTIQUE ▪ ▪ ▪ ▪

P FF PEECOL ™

tHE ULtimative TOY-FONT

FF PEECOL ©1998 eboy/vermehr, sauerteig — Distributed by FSI FONtSHOP International

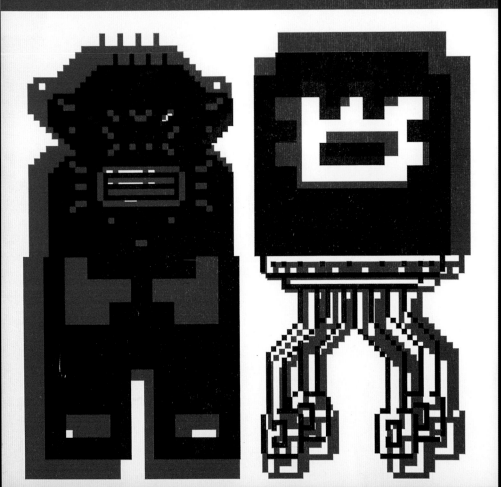

Peecol Posters created for FSI Fontshop International, Germany.

REECOL-Tank: Z

REECOL-Eb0t: ⇧0

REECOL-Play: t

FF REECOL™

REECOL

FF

Download Free FF REECOL-Test Font at:

www.fontfont.de
www.eboy.com

FF REECOL edited by eboy—Kai VeRMehR, sTeffen sauERteig — DisTRibuTed by FSI FontShop inTeRnational

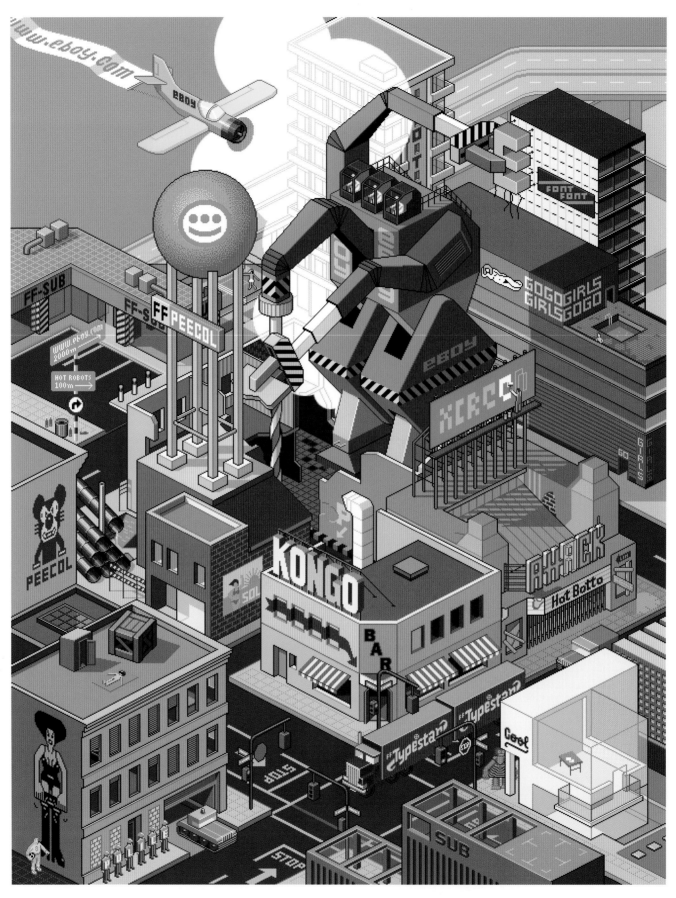

An illustration created by eboy called
eCity published by Auras, Inc., Japan,
in 1998.

"Huntington Beach," above, was created for *SPIN* magazine while at right is another illustration for *ESPN* magazine.

FERNKOPIE

PRINCIPALS: Wim Westerveld,
Claudia Wittig, Matthias Wittig
FOUNDED: 1997

Schönhauser Allee 182
10119 Berlin
TEL: (49) 30 44 05 36 50
FAX: (49) 30-44 05 36 51
EMAIL: wittg.westerveld@snafu.de

fernkopie is a German/Dutch venture among Matthias and Claudia Wittig in Berlin and Wim Westerveld in Amsterdam. The three first worked together in 1995 on a design project for the Akademie der Künste in Berlin. It was then that they learned how their different approaches and skills were so complementary. fernkopie is an old-fashioned word that literally means "transmittance over a long distance," which describes their way of working together between two cities. Most of their clients are from the cultural sectors. According to Claudia, the fernkopie approach to its projects is "not devoted to design strangled by programmatic rules." Rather, the firm prefers "to portray the spirit of the content gently with visionary colors, type, and images. A subtle, purposeful magic in our designs is more important to us than pushing a specific personal style." fernkopie prides itself on its close working relationship with clients, photographers, lithographers, and printers. "This very intensive process should yield results that are at once original, sensuous, intuitive, but also effective and typographically refined."

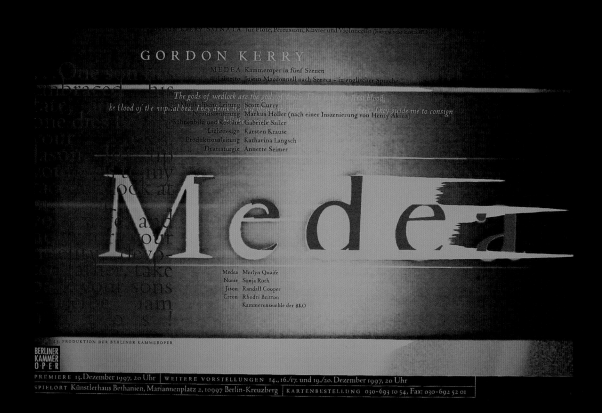

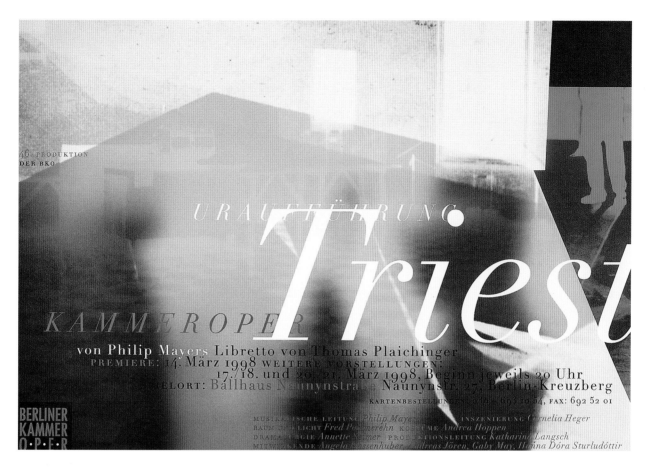

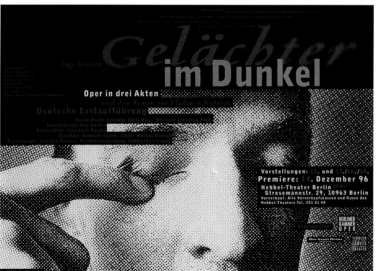

The Berliner Kammeroper (Berlin Chamber Opera) has commissioned fernkopie to produce a number of posters for performances such as these for *Medea*, *Triest* and *Gelächter im Dunkel*. Working closely with the directors, stage designers and conductors, fernkopie produces posters that are sensual, eye-catching introductions to the performances.These posters must also be visually strong enough to survive the information jungle of the Berlin subway.

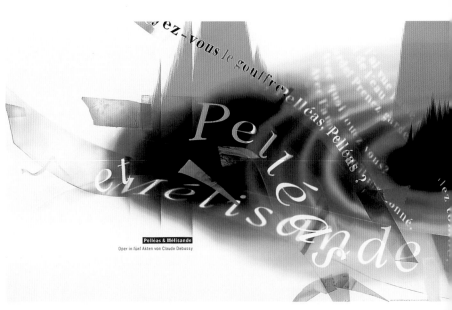

In this series of posters for musicals,
the designers make type the leading
actor. Its flow and rhythm creates a
sense of depth, musical expression
and drama.

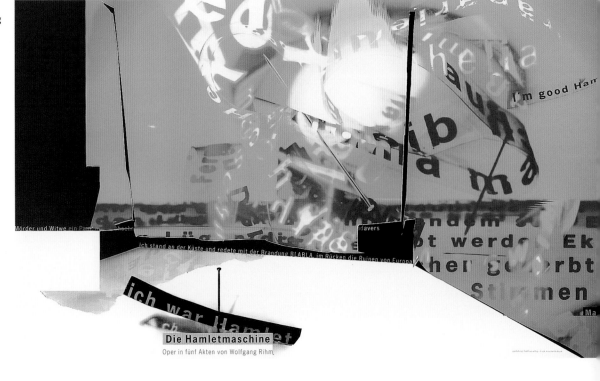

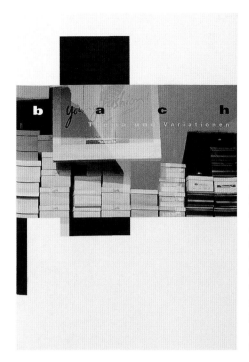

fernkopie's interest in translating content into design is demonstrated in the numerous books it has designed for cultural institutions. In *Bach, Themes and Variations*, the structural characteristics of the compositions of Bach were inspirations for typographic variations. The design becomes a fugue of light and darkness with the black rectangle serving as the key element in the visual translations of the music.

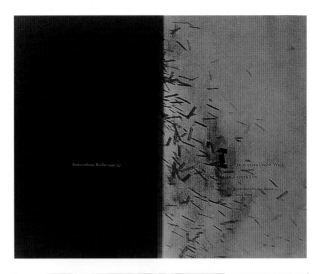

The Konzerthaus Berlin
commissioned fernkopie to design
this book that examines the ideas
of J.W. von Goethe, which were often
a source of inspiration for composers
and music interpreters. The great
variety of Goethe's ideas and
interests are visualized in a labyrinth
of layers. Every chapter opens with
scientific or artistic curiosities.

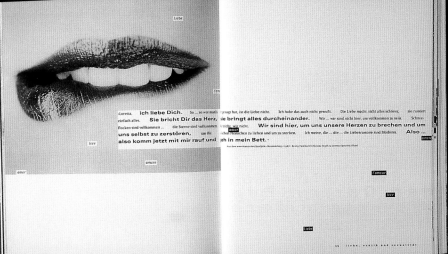

The designers attempted to match the main ideas of an extravagant exhibition, *Prometheus, Menschen, Bilder and Visionen* with pure typography, sometimes used boldly, other times subtly, in conjunction with striking black and white imagery.

Brauchen wir He

elden ?

The inspiration for the development of the visual identity of Berlin's ambitious millennium exhibition, *Seven Hills: Images and Signs of the 21st Century* was the symbiotic relationship between historic perspectives and the view of the future. The biomorphic logo is the nucleus of the design, symbolizing something that does not yet exist.

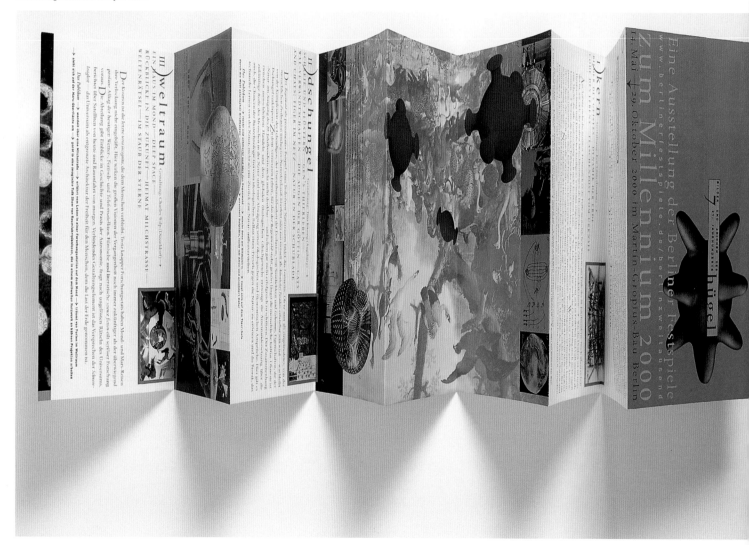

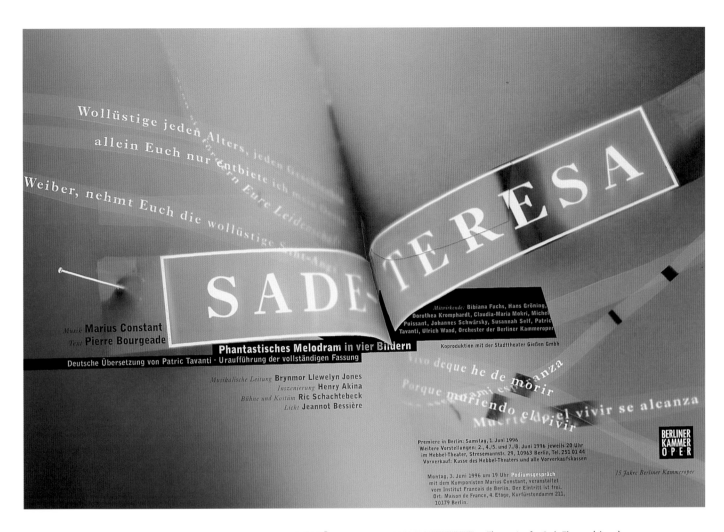

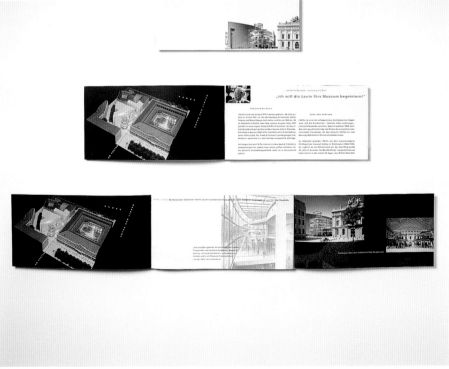

The poster for *Sade Theresa* (above), a modern opera dealing with the fictitious encounter between the Marquis de Sade and Saint Theresa, juxtaposes erotic with religious symbols. One of fernkopie's major clients is the Museum of German History (left). This brochure presents the architect I.M. Pei's design for an extension of the Museum.

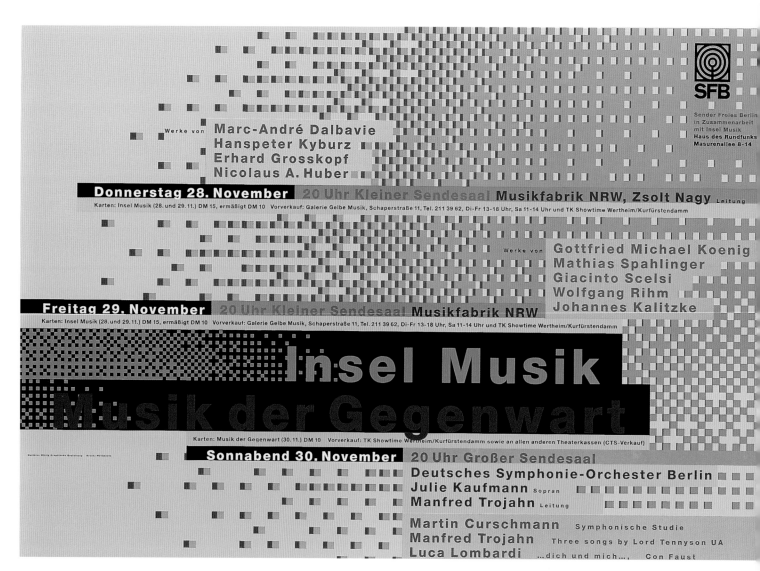

A series of posters for *Musik der Gegenwart*, which features concerts of challenging contemporary music compositions. In designing these posters, fernkopie attempts to appeal to those individuals with a very specific interest in modern music by visually mimicking it.

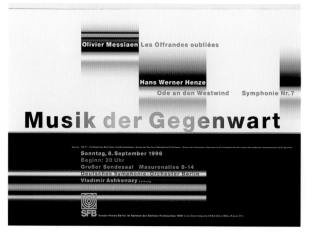

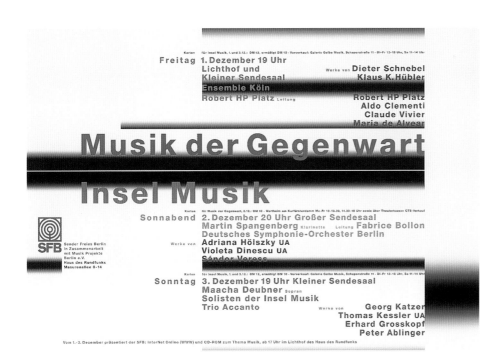

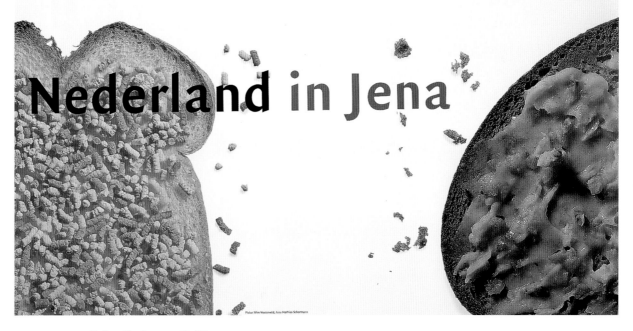

National foods are used in this poster announcing a cultural exchange festival between Dutch cities and the German city of Jena. On the left is a sandwich of sweet Dutch confetti and on the right is German lard on brown yeast-bread. Both delicacies are favorites in their respective countries.

PRINCIPALS: Jens Imig, Stefan Rothert,
Birgit Schlegel
FOUNDED: 1993

Stubenrauchstrasse 72
12161 Berlin
TEL: (49) 30 85 26 02 6
FAX: (49) 30 85 26 02 7
EMAIL: mail@gewerk.com
WEB: www.gewerk.com

GEWERK

The three principals of gewerk bring visual communication, industrial and graphic design to the table in creating identity programs and exhibition designs for museums, corporations, and transportation companies. gewerk's design philosophy is rooted in the belief that creative work requires the merger of a rational understanding of the design problem with an emotional twist. No project of gewerk better exemplifies this philosophical approach than their work with the Berlin Wall Memorial and Documentation Center that opened November 9, 1999, the tenth anniversary of the fall of the Wall. The involvement of gewerk in this highly important and emotional project was comprehensive. The firm not only collaborated on the concept and overall design of the Documentation Center, but also designed the printed materials, multimedia displays, interiors, and even the furniture. The most striking design element is the logo that they created for the Memorial, which is at once an abstract symbol and a realistic depiction of the Wall and the barrier to freedom that it represented.

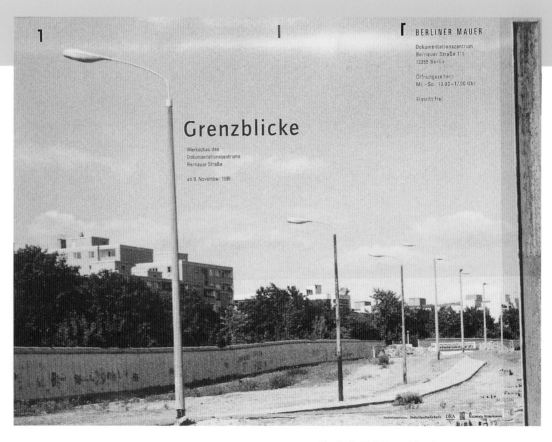

1 **⌐** BERLINER MAUER

The Berlin Wall Memorial and Documentation Center is a showcase for the talents of this multidisciplinary design firm. The Center's logo (left) is at once abstract and a realistic depiction of the Wall.

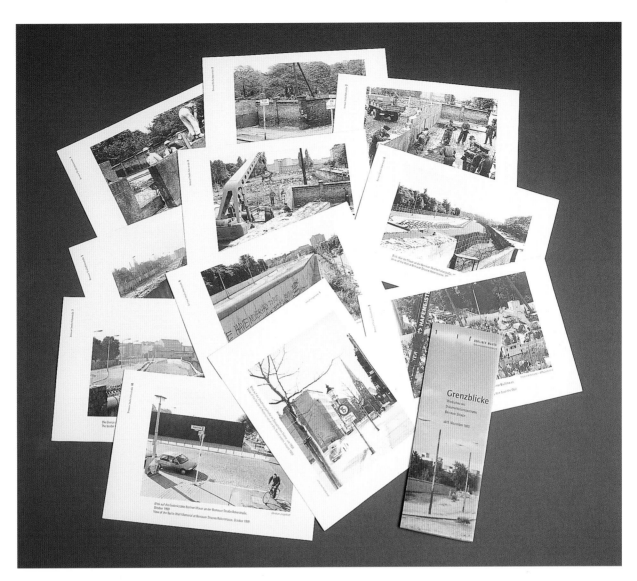

An information kit for the Berlin
Wall Memorial and Documentation
Center contains historical
photographs of the Wall.

FühlboxFühlbar was an exhibition at Hamburg's Stilwerk designed by gewerk dealing with the impact that different materials have on designers and users.

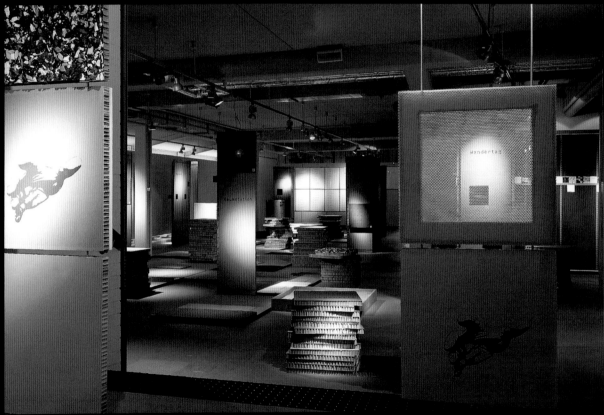

Used for self-promotion, this packet of brochures provides a comprehensive look at many of the projects for which the design team at gewerk has been commissioned.

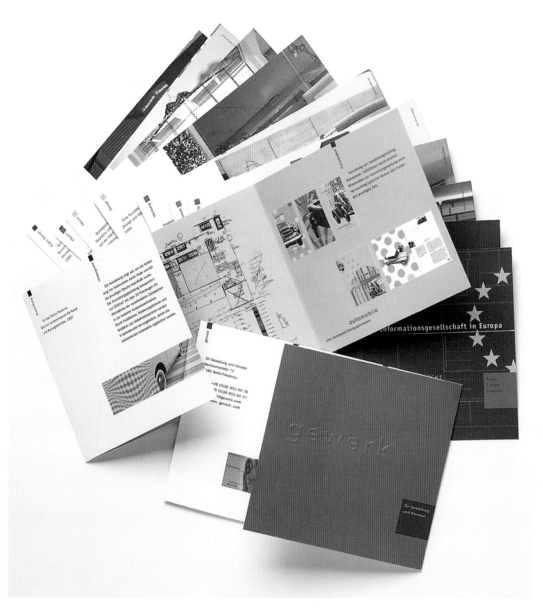

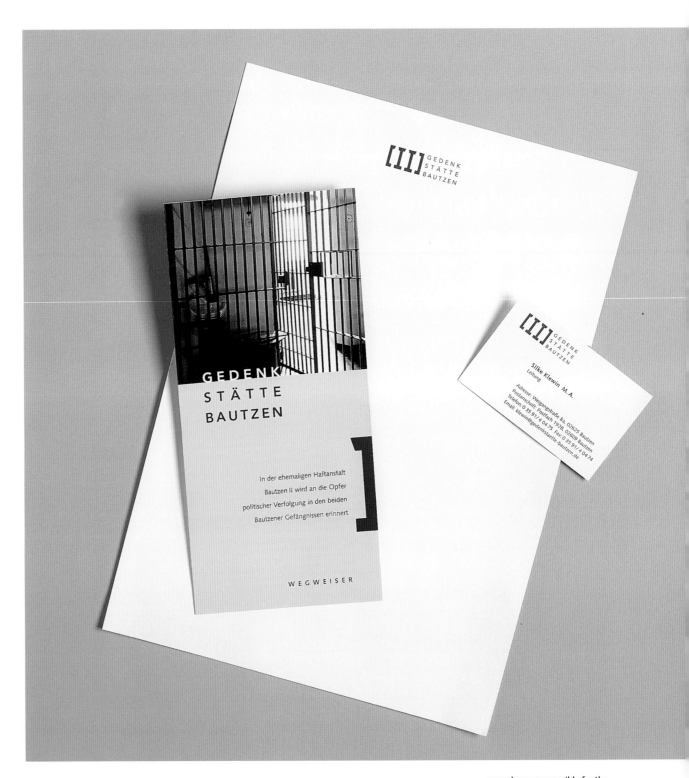

GEDENK
STÄTTE
BAUTZEN

GEDENKSTÄTTE
STÄTTE
BAUTZEN

In der ehemaligen Haftanstalt
Bautzen II wird an die Opfer
politischer Verfolgung in den beiden
Bautzener Gefängnissen erinnert

WEGWEISER

Silke Klewin M. A.
Leitung

Adresse: Weigangstraße 8a, 02625 Bautzen
Postanschrift: Postfach 1928, 02609 Bautzen
Telefon: 0 35 91 / 4 04 75 Fax: 0 35 91 / 4 04 74
Email: klewin@gedenkstaette-bautzen.de

gewerk was responsible for the
design of the promotional materials,
the interior design and the furniture
of the visitor rooms for the Bautzen
Jail Memorial. The Memorial informs
the visitor about the history of
political prisoners.

Corporate design for stationery,
business cards and an invitation.

PRINCIPALS: Andreas Trogisch, Ute Zscharnt, Heike Grebin
FOUNDED: 1997

Brunnenstrasse 24
10119 Berlin
TEL: (49) 30 44 34 29 71
FAX: (49) 44 10 71 5
EMAIL: blotto@grappa.net
WEB: www.grappa-net.de

GRAPPA BLOTTO

The original grappa was founded in East Berlin in 1989, just months before the Wall came down. In contrast to the oppressive system into which grappa was born, the firm celebrated individual creativity and strong political commitment. In 1992, Detlef Fiedler, one of the original founders, along with Daniela Haufe, who had joined grappa in 1991, left to form cyan. grappa split again in 1997, with partners Andreas Trogisch, Ute Zscharnt and Heike Grebin forming grappa blotto, and partners Dieter Feseke and Kerstin Baarmann forming grappa.dor. This division of grappa did not diminish the creative energy of the partners as the graphically powerful work of grappa blotto attests. Continuing the grappa tradition of working with cultural organizations, grappa blotto combines classic modernism with a masterful use of type and photography to create posters and books with an edgy, highly individualistic appeal.

Ordinary urban scenes are captured in the extraordinary symmetry of this gallery poster designed by Stefan Stefanescu and Ute Zscharnt.

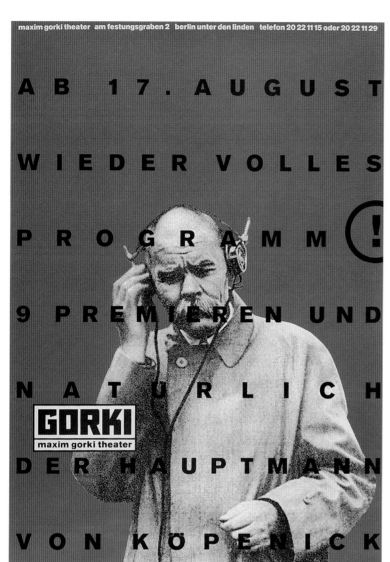

The Gorki Theatre in Berlin has long been a client of grappa blotto and over the years all of the partners have had a hand in designing posters, programs, and ephemera for the theatre.

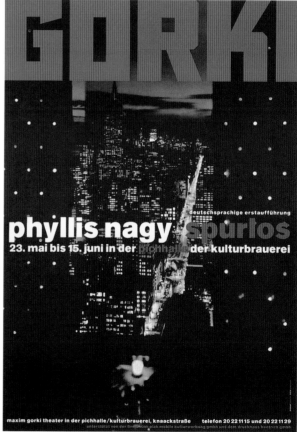

These three spreads for a journal are (top to bottom) Contrast-Soul designed by Dieter Feseke; Contrast-Space designed by Ute Zscharnt; and Contrast-Time designed by Andreas Trogisch.

JESSICA BUEGE TOM HARTLE COLETTE HOSMER PETER JOSEPH
JON MC CONVILLE HEATHER ROGERS SIMPARCH TABI
ERIKA WANENMACHER MICHAEL WEBB

SHIP FROM THE DESERT
THE MOORINGS PROJECT

BRANDENBURGISCHER KUNSTVEREIN POTSDAM E.V.
PLAN B EVOLVING ARTS SANTA FE
KURATORIN CHRISTINE HOFFMANN PROJEKTKOORDINATION ZANE FISCHER MICHAEL LUJAN

MASCHINENHALLE SCHIFFBAUERGASSE 1 14467 POTSDAM
EROEFFNUNG SAMSTAG 12. SEPTEMBER 21 UHR
23 UHR DJ BLUE MINH (ICON CLUB / BERLIN) DRUM & BASS AVIATION / DOWNTEMPO XERO SOUNDS

13. SEPTEMBER BIS 4. OKTOBER 1998 DIENSTAG BIS SONNTAG 14 BIS 20 UHR TEL/FAX (0331) 29 83 58

MIT FREUNDLICHER UNTERSTUETZUNG / CITY OF SANTA FE ARTS COMMISSION / STIFTUNG KULTURFONDS BERLIN /
LANDESZENTRALBANK BERLIN UND BRANDENBURG / KULTURAMT DER STADT POTSDAM / MINISTERIUM FUER
WISSENSCHAFT FORSCHUNG UND KULTUR DES LANDES BRANDENBURG / LANDESENTWICKLUNGSGESELLSCHAFT DES
LANDES BRANDENBURG MBH / MAERKISCHE ENERGIEVERSORGUNG AG

Although printed in only two colors, the blistering heat of the desert is effectively rendered in this design by Tilmann Wendland based on photography by Saskia Wendland for the *Brandenburgischer Kunstverein*, Potsdam. The font is Typestar OCR.

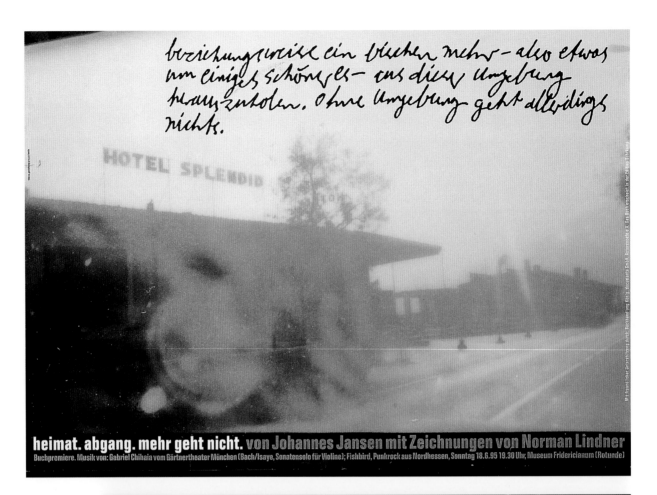

beziehungsweise ein bißchen mehr - also etwas
um einiges schöneres - aus dieser Umgebung
herauszuholen. Ohne Umgebung geht allerdings
nichts.

heimat. abgang. mehr geht nicht. von Johannes Jansen mit Zeichnungen von Norman Lindner
Buchpremiere. Musik von: Gabriel Chihaia vom Gärtnertheater München (Bach/Isaye, Sonatensolo für Violine); Fishbird, Punkrock aus Nordhessen, Sonntag 18.6.95 19.30 Uhr, Museum Fridericianum (Rotunde)

While both of these posters
announce an architectural
exhibition, and both are printed in
black and white, the designs are
dramatically different. The first,
designed by Ute Zscharnt, is soft
and impressionistic while the
second, designed by Andreas
Trogisch, is filled with the tension
and electricity of the city.

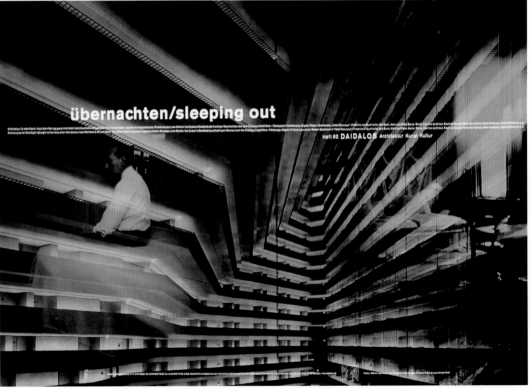

übernachten/sleeping out

Heft 62 DAIDALOS Architektur Kunst Kultur

Bold geometry carries the day in this poster designed by Heike Grebin, Ian Warner, and Tilman Wendland.

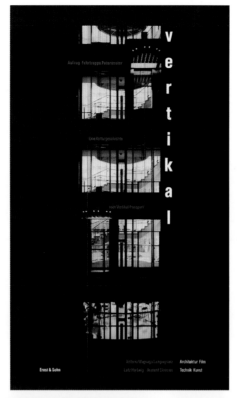

All things vertical is the theme of this book design by Andreas Trogisch for the publisher Ernst and Sohn. Particularly compelling is the manner in which the photography and type are used to develop the theme.

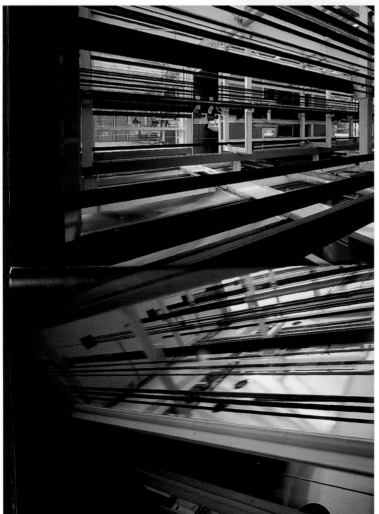

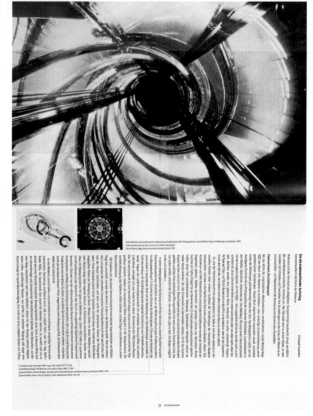

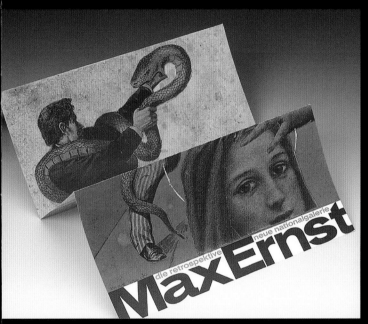

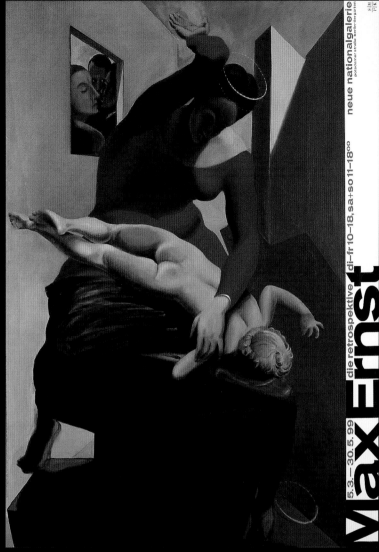

The designers are particularly adept at using original art to create designs that are uniquely their own. Here, Ute Zscharnt and Stefan Stefanescu used that approach to produce tickets, posters, flyers and invitation cards for an exhibit for Max Ernst at the Neue National-galerie Berlin.

PRINCIPALS: Kerstin Baarmann, Dieter Feseke,
Frenk Döring, Sanne Dijkstra
FOUNDED: 1997

Zehdenicker Strasse 21
10119 Berlin
TEL: (49) 30 44 35 84 00
FAX: (49) 30 44 35 84 01
EMAIL: dor@grappa.net
WEB: www.grappa.net

GRAPPA.DOR

In an interview in a Japanese magazine last year, Kerstin Baarmann summed up the design esthetic of grappa.dor, which was formed when the highly successful and influential grappa studio split into two firms in 1997: "We enjoy using old fashioned printing techniques (stamps, typesetting, seals, etc.). The texture of the material (paper, carton paper, etc.) is something a computer cannot convey...it is important to know printing techniques and use printing techniques in the designing process to do something a computer cannot. Printing is the final stage in the design process, and it is what determines the quality of the design." This hands on approach is clearly evident in the posters grappa.dor has created for its many clients in the world of culture.

The Bauhaus has long been a grappa client. These two-color posters using photography and stark modernist design are typical of the work for this client.

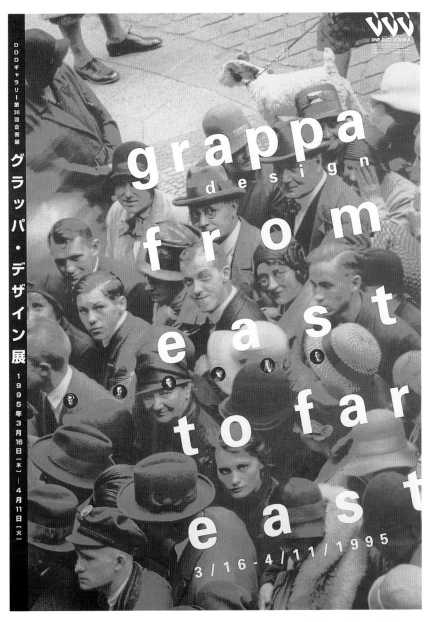

grappa.dor's creative work is known world-wide. An exhibition (above) was held in Osaka, Japan, in 1995. Work in Asia includes this calendar/poster for CDR Associates in Seoul, Korea.

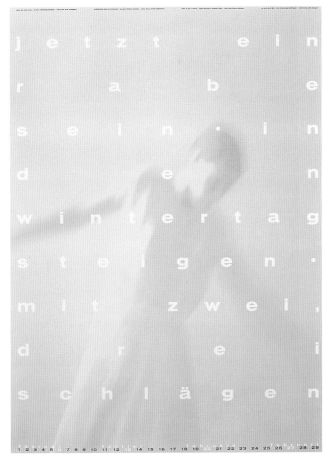

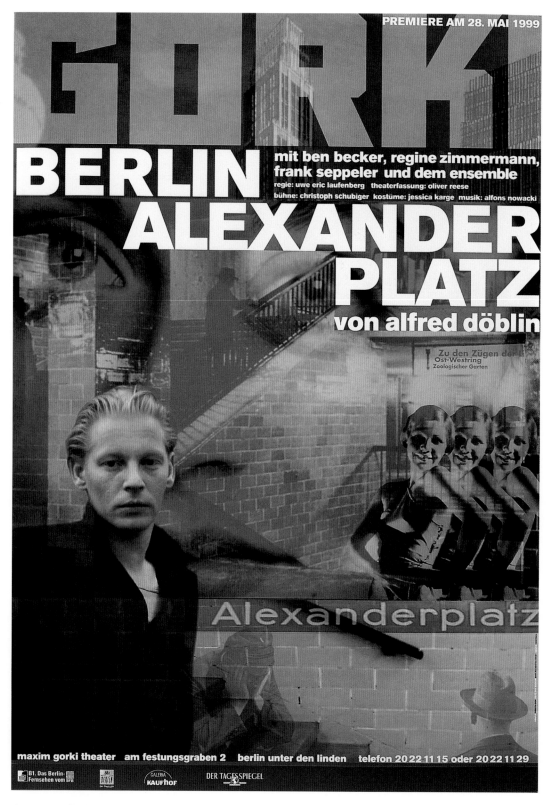

The Maxim Gorki Theatre in Berlin
has been a client for many years.

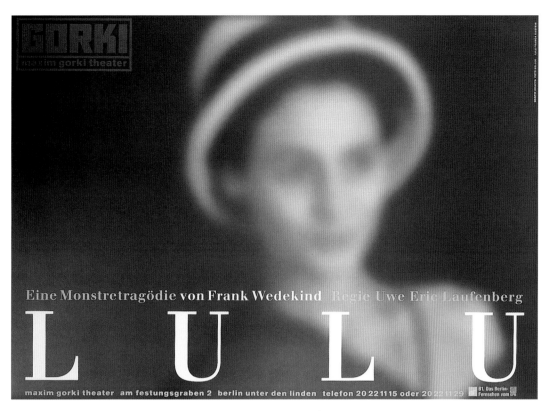

GORKI
maxim gorki theater

Eine Monstretragödie von Frank Wedekind Regie Uwe Eric Laufenberg

L U L U

maxim gorki theater am festungsgraben 2 berlin unter den linden telefon 20 22 11 15 oder 20 22 11 29

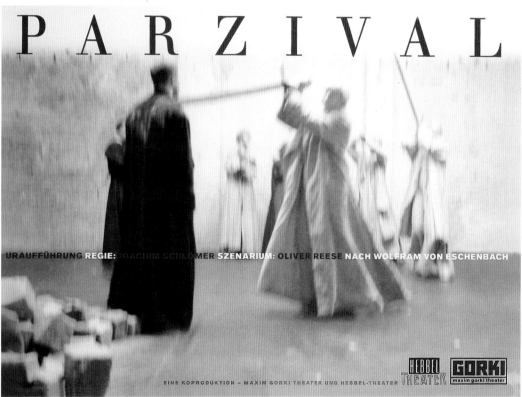

PARZIVAL

URAUFFÜHRUNG REGIE: JOACHIM SCHLÖMER SZENARIUM: OLIVER REESE NACH WOLFRAM VON ESCHENBACH

HEBBEL THEATER GORKI maxim gorki theater

EINE KOPRODUKTION – MAXIM GORKI THEATER UND HEBBEL-THEATER

dois **zwei**

LILO C. KARSTEN DEUTSCHLAND/ALEMANHA, MARCIA PARAHYBA BRASILIEN/BRASIL
INSTALLATIONEN UND ARBEITEN AUF PAPIER/INSTALA COÉS E TRABALHOS EM PAPEL
ERÖFFNUNG 5. MAI 99 19.30 KVD GALERIE DR. ENGERTSTR. 9 HINTEN 85221 DACHAU 6.–30. MAI 1999 MI–FR 16–20 SA–SO 14–18

KVD
KÜNSTLER
VEREINIGUNG
DACHAU E.V.

Rarely working with more than one
color and black, grappa.dor never-
theless is able to create an astonish-
ingly diverse body of work for its
clients in the culture sector including
galleries, museums, the theatre,
and film.

21.

moderato.

SAMSTAG · 8. MAI 1999 · 17 UHR KONZERTHALLE »CARL PHILIPP EMANUEL BACH«
KONZERT MIT JUNGEN SOLISTEN AUS DEN MUSIKSCHULEN DES LANDES BRANDENBURG
UND DEM STAATSORCHESTER FRANKFURT (ODER) DIRIGENT: FRANZ KRÜTZSCH
SOLISTEN JEANNINE TITTELBACH · SOPRANFLÖTE · MICHAELA NIEDERMEYER · KLARINETTE · JOHANNA ESCHENBURG
VIOLINE AUS FRANKFURT (ODER) STEFAN WENDT · GITARRE AUS EBERSWALDE REBECCA SCHULZE-WINDOLF · ILKA HENNIG
GESANG AUS SCHWEDT/ODER FERDINAND HENDRICH · POSAUNE NAPOTSDAM BENJAMIN THOMS · OBOE · JOHANNES KEIL
VIOLINE AUS RATHENOW FABIO HAKE · FLÖTE GAST AUS NRW

MUSIC SOLIDAR

ZUGUNSTEN DES PARITÄTISCHEN WOHLFAHRTSVERBANDES · FRANKFURT (ODER)

1999

HEINER
CAROW

RETROSPEKTIVE/SEPT/OKT/1999

BABYLON
BERLINER FILMKUNSTHAUS

THE LEGEND OF THE GOLDFISHBOWL

PRINCIPALS: Markus Hayn, Tobias Willemeit
FOUNDED: 1992

Mommsenstrasse 47
10629 Berlin
TEL: (49) 30 32 79 33 0
FAX: (49) 30 32 47 91 0
EMAIL: info@hayn-willemeit.de

HAYN/WILLEMEIT

A sense of inspired clarity and craftsmanship pervades the work of Hayn/Willemeit, a firm whose portfolio combines projects based in the world of fine art and architecture with those in corporate and institutional communication. This may lead to a rather subjective, almost cryptic imagery such as was developed for the 1999 Berlin Biennale or it can lead to a design concept focusing clearly on product benefits, as Hayn/Willemeit designed for Campina Melkunie, a producer of consumer dairy goods. Skilled in the pre-Mac era, founders Markus Hayn and Tobias Willemeit believe in a conceptual approach which includes aesthetic decisions at an early stage in the process. The concept then defines the way different media contribute to the communication process. In the case of Berlin Hyp, it involved the design of an entire range of carefully harmonized communication devices including the logo, corporate design manual, brochures, the Internet and CDs.

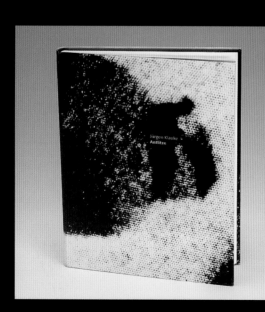

The publication of Jürgen Klauke's latest project presents his collection of "Antlize," or faces, which consist of photographs appearing in newspapers of people wearing masks, some for protection and some for camouflage. The artist worked closely with the creative director, Peter Hansen. Markus Hayn designed the book.

Geschäftsbericht 1998

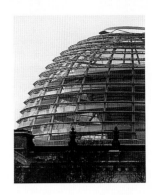

Berlin Hyp

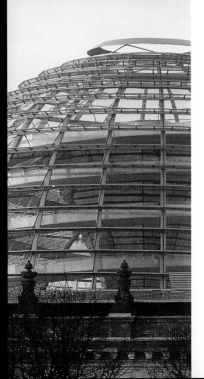

Geschäftsbericht
1998

Berlin Hyp

Architect Sir Norman Foster's glass
dome atop the Reichstag makes
a powerful visual reference point
for this corporate design program
for the Berlin-Hannoversche
Hypothekenbank AG. Hayn/
Willemeit created the logo as well
as a complete design manual.
They are responsible for designing
the annual report each year both
for print and CD ROM. The photog-
raphy is by Gerhard Kassner.

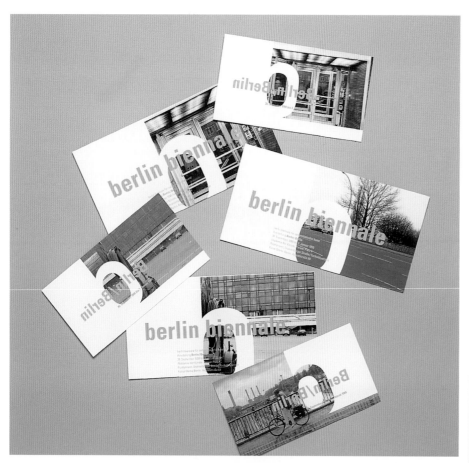

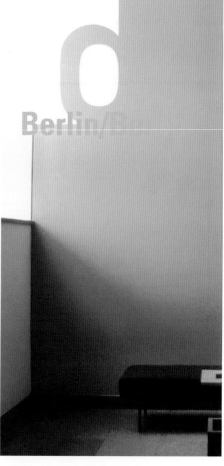

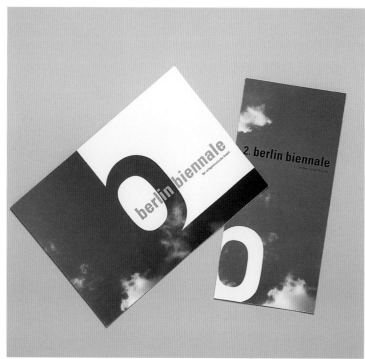

The first Berlin Biennale featured the work of more than 70 international artists under the banner *Berlin/ Berlin*. Hayn/Willemeit created the visual concept employing simple graphic elements derived from the logo. Markus Hayn's unusual and often surprising views of the city that were incorporated into the printed materials reinforced the fact that most pieces of art in the exhibition were either produced in Berlin or made especially for this Biennale.

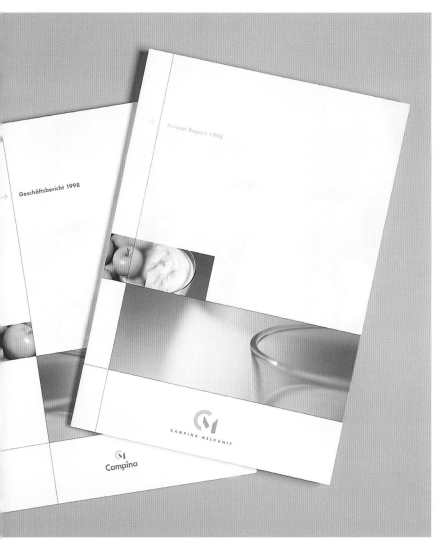

The Fascinating World
of Dairy Products

For the corporate image campaign for Campina Melkunie, a producer of consumer dairy products, Hayn/Willemeit focused on visualizing the experience of taste. The photographs are by Ella Klaschka, Peter Hansen and Philipp Götz; Anke Ripper was the art director.

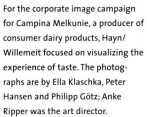

PRINCIPALS: Claudius Lazzeroni, Klaus C. Ulbricht, Holger Castritius, Kaniela V. Heyl
FOUNDED: 1996

Kastanienallee 84
10435 Berlin
TEL: (49) 30 44 37 28 0
FAX: (49) 30 44 37 28 28
EMAIL: miss.lovebyte@imstall.com
WEB: www.imstall.com

IM STALL

im stall emerged in 1996 when, according to the studio, "the first multimedia hype was over and most 'clicks' seem to have been invented." Founders Lazzeroni (design), Castritius (concept) and Ulbricht (marketing) were determined to give birth to a new agency approach that would focus first on thought and expertise rather than computer tools and programs. im stall settled in a backyard in Prenzlauer Berg, the East Berlin hang-out area and begin seeking clients that shared their ideas about computers, the Internet and marketing. One can touch, watch, listen or click the work that Claudius Lazzeroni is responsible for designing. Interactivity is the name of the game for im stall and game-like concepts often figure prominently in their work. For an invitation for the opening of the Berlin-based Museum of Things (Museum der Binge) im stall created an elaborate box with pictures and miniature reproductions of objects from the museum. For the electronic pop venture Quarks, im stall created real-life objects such as perfume for fictional characters.

Created by im stall, "Brainsaver zen 2000" is billed as the slowest play in the world on disk.

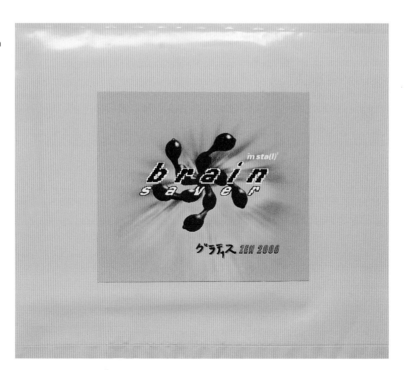

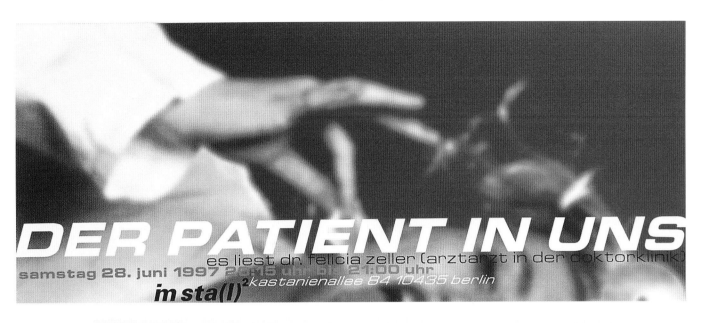

DER PATIENT IN UNS
es liest dr. felicia zeller (arztarzt in der doktorklinik)
samstag 28. juni 1997 **23:15** uhr bis 21:00 uhr
*im sta(l)*²*kastanienallee 84 10435 berlin*

oss lewis *dancing in pink snow*
 installation

Adjacent to im stall's studio is a
small gallery that was once a horse
stall (hence the name of the firm). im
stall now uses the space as a gallery.
These are invitation cards created by
im stall for recent exhibits.

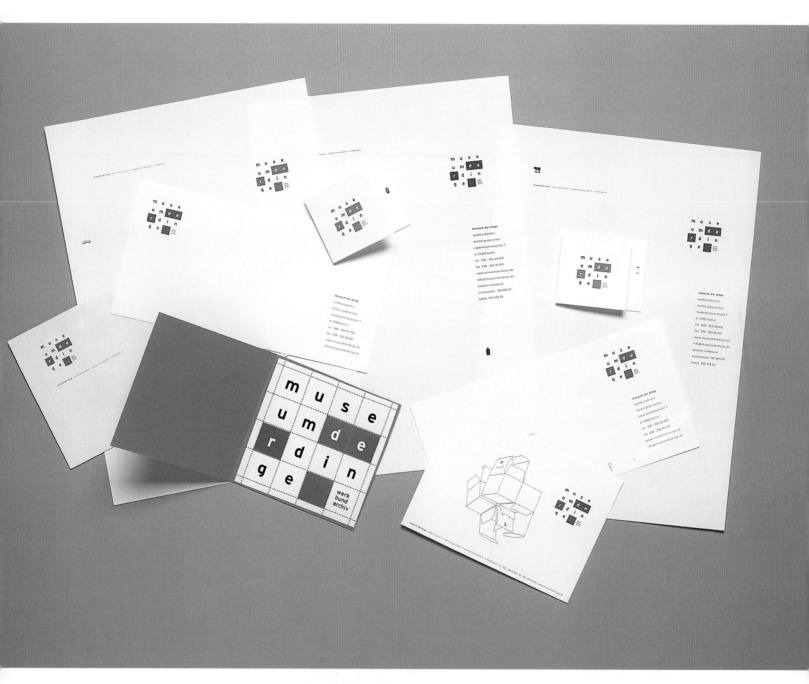

Corporate design and logo-
development for the Museum
of Things at the Martin-
Gropius Building in Berlin.

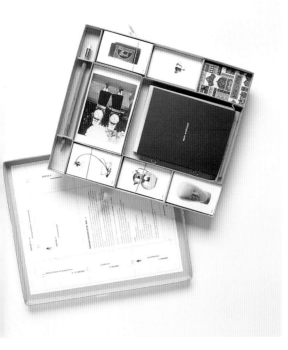

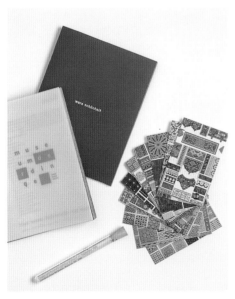

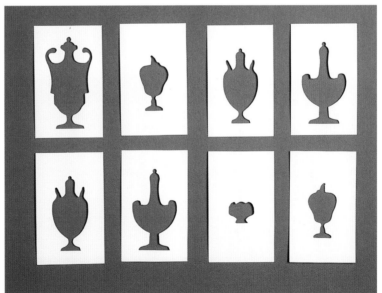

As part of the corporate design
program for the Museum of Things,
im stall created this box of "things"
from the Museum's collection.

Head·Room 2.0

GENERAL DESCRIPTION

Head-Room is the first realtime capable plugin for muscle based facial (and non-facial) animation. It plugs into 3D Studio MAX and fits seamlessly with Character Studio. The muscle deformation approach is a new approach for facial animation as traditional animation uses morph targets with its limited bandwidth of expressions. Muscle deformation can coexist with morph targets and can even be used to design morph targets fast and efficiently. The unique muscle toolkit within Head-Room is realtime capable, i.e. by using an input device like a mouse or a X-IST FaceTracker the animator can realize the facial movements in realtime, live! The biological algorithm based software has been made available to a selected group of animators which have proved with exciting projects the benefit of working with Head-Room.

The 3D Studio MAX user can use Head-Room to animate realistic faces by muscle deformation which is the approach nature did and which is the most successful deformation strategy for communication purposes on this planet. Muscles can be used do provide primary movement of large areas of skin or subtle movement (micromotion) to add life to your characters. All the muscle animations done with Head-Room merge seamlessly with Character Studio and can be exported to X-IST VuppetMaster for realtime performances. Head-Room 2.0 is compatible with MAX R3.0 and comes with the following modules:

D-FORM is the actual muscle toolkit. It allows the selection of different types of muscles, the attachment of the muscle to a geometry (skin) and the definition of force tension and region of influence. Immediately after setup of a muscle you can check the behavior of the muscle in realtime by dragging it with the mouse. Of course you can keyframe these phases or use any input device to control the muscles. Using several muscles together you add realism by defining influences and fall-offs. All the muscles can be animated in realtime. The entire muscle system can be saved and loaded independently of the objects and can be applied to different geometries for creating a reusable library of muscular systems. A wrinkle muscle allows even more deformation effects on your mesh.

D-FORM can be installed free for rendering in networks and render farms.

X-TAG is a toolkit for controlling the movement of the muscle system in 3D space. Any 2D movements can be used for controlling the muscle handles and the advanced "Automatic Handle Transformation" allows the X-TAG object to follow the local deformation of the object.

FACECAP is a realtime motion capture controller for facial captured data coming from facetrackers or other input devices either attached online via a serial or network link or offline using a motion file. It solves the assignment of input channels to output channels. As a bonus, use FACECAP for the creation of realistic finger/data glove animation right inside MAX.

X-WARP is a module for morphtarget based expressions. The advantage of X-WARP is the capability of using it in realtime with an input device. It is a unique Morph-Controller.

XRC MOTION IMPORT is used for importing motion data files from the new X-IST FullBodyTracker into CharacterStudio and apply this data to your biped characters. Create motion captured body, face and finger animation simultaneously in MAX.

MOTION MARKER EXPORT is the link back to X-IST VuppetMaster for exporting any MAX animation either offline or online to the realtime software VuppetMaster. See any animation results immediately in realtime on your characters.

HEAD-ROOM DOOR opens the door of Head-Room for developers. It allows the design of door applications which can make use of all major functions within Head-Room.

FACESET demonstrates the power of the HEAD-ROOM-DOOR SDK as a powerful tool for the animator to design muscle based targets which can be used for keyframe animation.

Head-Room is a product of X-IST Realtime Technologies, the company dedicated to design and distribute solutions for realtime motion tracking and realtime animation.

SHORT DESCRIPTION

Plug-In for 3D Studio MAX:
realtime capable and keyframe "morph look and feel"
supports X-IST FaceTracker
realistic facial expressions through muscle simulation
different muscle types, forces, tensions, regions
open plugin structure allows custom applications

BUNDLE - OFFERS

Head-Room with X-IST FaceTracker incl. /excl. PC
Head-Room with X-IST FaceTracker and VuppetMaster
(head version)

GET IN TOUCH

X-IST Realtime Technologies GmbH
Hans-Boeckler-Str. 163, 50354 Huerth, Germany
Phone: +49 22 33 518000, Fax: +49 22 33 518089
info@x-ist.de
www.x-ist.de

US RESELLER

2-G Motion Inc.
7403 Walling Lane, Dallas, TX 75231
Phone: 214-343 1348, Fax: 214-343 1318
kgraves@wtd.net
www.2gmotion.com

X-IST, Vuppet and VuppetMaster are registered trademarks of X-IST Realtime Technologies GmbH, Huerth. ©2000 Deutscher Gebrauchsmusterschutz. All other brand names and trademarks belong to their respective owners.

DataGlove

Head·Room 2.0

FullBodyTracker

FaceTracker

Corporate design for a Web site and data sheets for S-IST Realtime Technologies, a manufacturer of devices that track human movement for computer animation applications.

This corporate design and logo were developed for noDNA, a company that creates virtual characters. To help give these characters life, im stall created a virtual perfume (right).

PRINCIPALS: Dominika Hasse, Bruno
Bakalovic, Dietmar Mühr
FOUNDED: 1990

Köpenicker Strasse 48/49
10179 Berlin
TEL: (49) 30 30 86 36 0
FAX: (49) 30 30 86 36 99
EMAIL: k-plex@k-plex.de
WEB: www.k-plex.de

K/PLEX

Since its founding, K/PLEX has positioned itself as a multidisciplinary corporate identity firm with a staff of graphic designers, architects, computer scientists, business consultants, copywriters and production specialists all under one roof. "Today, corporate identity no longer means freezing uniform design and behavior in static corporate identity manuals," according to Dietmar Mühr. K/PLEX sees corporate identity as a management tool for strategic change within the corporation.

K/PLEX's design philosophy has been well tested in its ongoing relationship with the "art forum berlin," an annual art fair for which K/PLEX designed the logo and each year creates posters, brochures, advertising campaigns and the website for the fair. While the basic structure and look of the fair was created at the very beginning, each year K/PLEX uses this structure to create a fresh look, even replacing the name of the fair in 1999, with the exclamation, "Buy more art!"

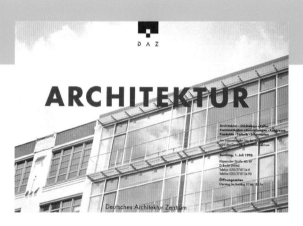

The German Architecture Center Berlin (DAZ) is an important contributor the discourse about architecture in a city where architecture is on everyone's mind. K/PLEX developed the crisp identity program for the Center which included signage, posters, and brochures.

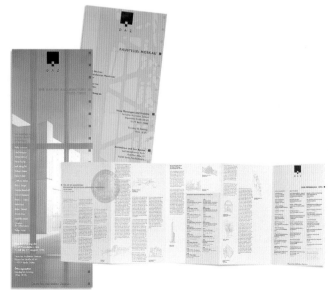

The design for the 1997 Annual Report for the International Design Center Berlin is a visual reflection of the effect of new media on print design. Common principles of illustration and text editing were disregarded.

The 50-year-old Free University, one of Germany's largest, wanted a more contemporary image. To accomplish this, K/PLEX employed a fresh color pallet of blue and apple green. Bold "fold marks" define the layout grid. And only a segment of the University's traditional seal appears amid rows of of colorful squares at the heading, in which illustrations and photographs are printed.

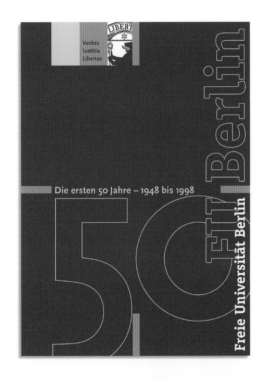

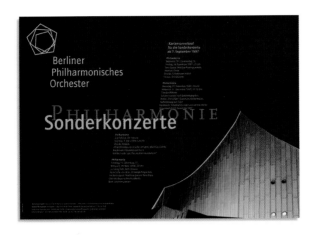

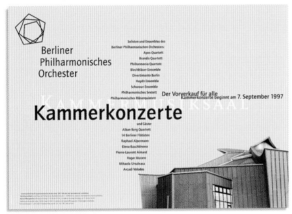

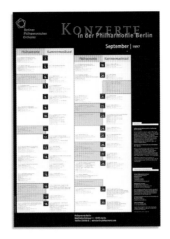

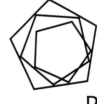

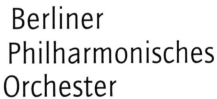

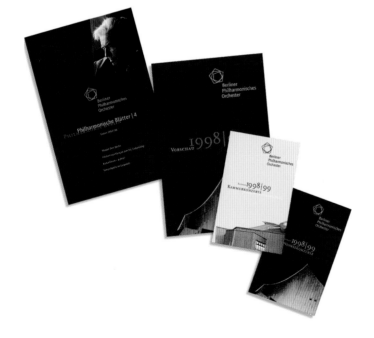

Berliner
Philharmonisches
Orchester

The Berlin Philharmonic Orchestra is one of the great symphony orchestras in the world. In 1997, K/PLEX was commissioned to redefine its visual image. The triple pentagon, which symbolizes the unity of space, music, and man, became not only the logo but also the basis for all other design decisions. Angles that occur in the pentagon of the signet are adopted in the typographical design. Both concert halls appear on all posters and programs for concerts.

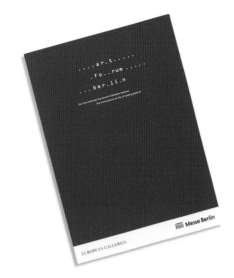

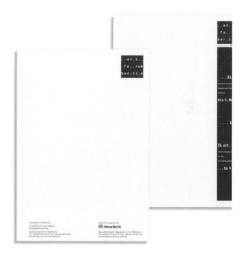

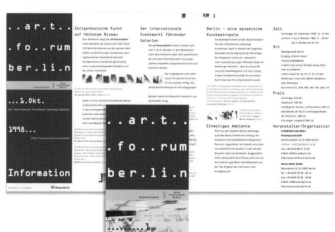

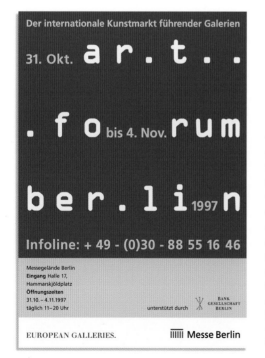

The central element for the
corporate design for Art Forum
Berlin is a blue square in which all
information pulses in continuous
ticking lines. The blue info-logo
dominates all advertising
campaigns, brochures, and the web
site. In an advertisement for the
cinema, the logo becomes a moving
screen. For promotions at
international art events, K/PLEX
developed cube clothes from the
blue square. These "incubators"
were worn as walking billboards at
the events.

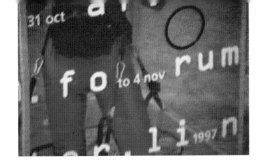

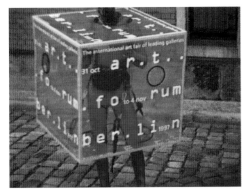

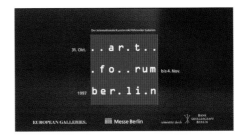

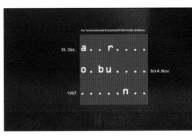

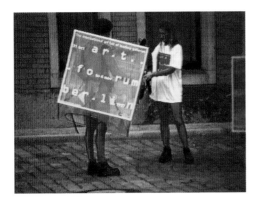

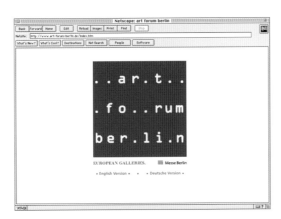

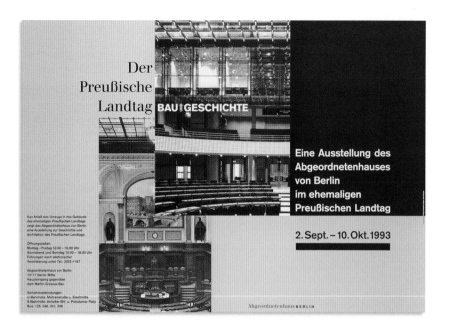

After the fall of the Wall, the Berlin State Parliament, the House of Representatives, moved to the former Prussian State Parliament building located in the eastern section of the city. In designing the corporate identity for the House, K/PLEX created a restrained and dignified portfolio of printed materials.

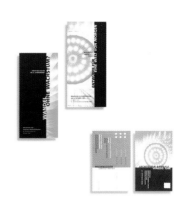

The theme for the German pavilion at the VI Biennial Architecture Festival in Venice was the revitalization of the Ruhr region of Germany. The design is dominated by the choice of colors: black, the color of the Ruhr area, represents coal; green, the color of nature, symbolizes new projects to revitalize this industrial area.

PRINCIPALS: Priska Wollein, Alessio Leonardi
FOUNDED: 1997

Boeckhstrasse 21
10967 Berlin
TEL: (49) 30 69 80 93 42
fax: (49) 30 69 80 93 55
email: priska@leowol.de
web: www.leowol.de

LEONARDI.WOLLEIN

Alessio Leonardi and Priska Wollein met while studying visual communications at the ISIA in Urbino, Italy. In 1990 they both moved to Berlin and joined MetaDesign. Wollein worked for MetaDesign for five years in Berlin and in the San Francisco office. She was in charge of complex CD projects for Audi and the Berlin Tourism Marketing agency. Leonardi is a well known type designer who, over the years, has designed numerous contemporary fonts which are available from internationally renowned type foundries such as Linotype Library and FontShop. In 1995, with two partners, he founded Fontology in Piacenza, Italy where he hopes to revive the tradition of Italian typography.

Leonardi's skills with type and Wollein's strong visual sense are clearly evident in the work that is developed at their Berlin studio. Leonardi.Wollein, now a team of eight graphic designers, has drawn up corporate image campaigns for such diverse clients as the pharmaceutical firm Schering AG, the fashion label CECIL, and Linotype Library. For the French art magazine *L'OEIL*, the designers took the magazine back to its beginnings in the 1960s, returning it to the strong typography and layouts for which it was known at the time.

At Leonardi.Wollein, every employee has his or her own "packaging" by choosing a product to illustrate business cards and other in-house promotions.

This well-known art magazine was redesigned with the new design reflecting its original look when it was founded in the 1960s. The design is restrained, and does not compete with the art.

LinotYpE

As an indication of how highly
respected this studio is, it was asked
to design the quarterly newsletter
and its logotype for the prestigious
Linotype Library.
Designers: Alessio Leonardi,
Imme Werner
Photographer: Edgar Lissel

WBMI
Geschäftsbericht 1997
WBMI Wohnungsbau- & Investitionsgesellschaft Berlin-Mitte mbH

The annual report for WBMI Wohnungsbaugesellschaft Berlin (the public housing authority) features a close-up view of the crowning architectural achievement of the former East Berlin, the Television Tower. Although the budget for this report was limited, the designers used carefully cropped images to give it a strong visual appeal.
Designer: Katrien Stevens

Privatisierung

This is an employee incentive program for the the Shering pharmaceutical company. The logo says it all: "Your ideas get it going." The incentive program is designed to motivate employees to come forward with ideas for improvements in the company's operations.

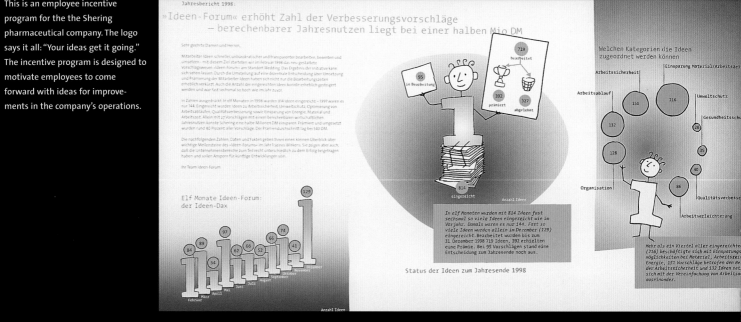

The client wanted a giveaway to be developed for participants in an international management congress that related to the theme of the congress: "Grow Together". The designer's solution was to design templates that were attached to pumpkins and let nature do the rest.
Designers: Felix Steffen,
Priska Wollein

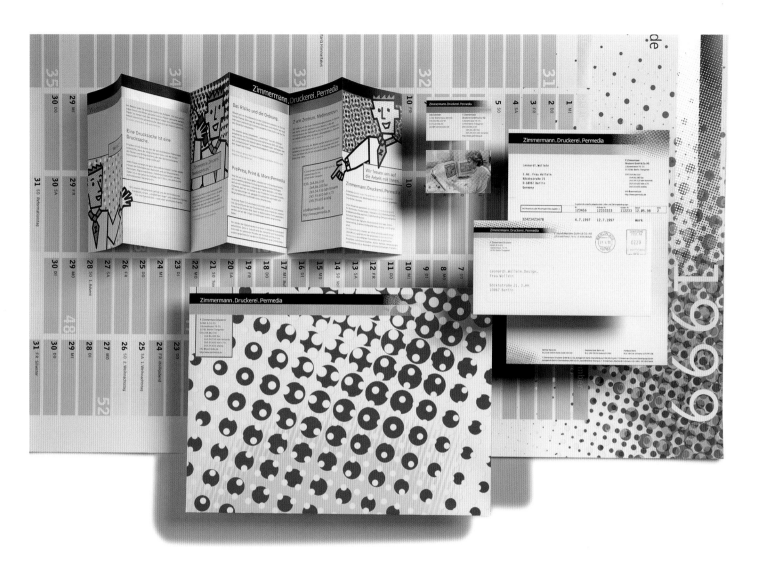

As part of a corporate identity
campaign for Druckhaus
Zimmermann, a printer, the
designers created a special font
made up of dots to create a
background of images. In order to
create the logo, the user types in a
certain sequence of keys; no other
files such as eps or tifs are necessary.
Designers: Alessio Leonardi,
Priska Wollein, Imme Werner,
Kai Herse

PRINCIPALS: Heike Nehl, Sibylle Schlaich, Heidi Specker
FOUNDED: 1994

Nollendorfstrasse 11/12
10777 Berlin
TEL: (49) 30 21 50 08 8
FAX: (49) 30-21 50 08 9
EMAIL: info@moniteurs.de
WEB: www.moniteurs.de

MONITEURS

The founders of Moniteurs, Sibylle Schlaich, and Heike Nehl are graphic designers while Heidi Specker is a photographer and computer graphics designer. The firm specializes in developing complex design projects for corporations, exhibition designers, and mail order companies using print, the Internet, and video. Moniteurs has an international reputation for its use of typography and much of their design work starts with a typographical approach. "Our graphic language is defined by the common denominator of the matching forms and meanings of signs and images. We see typography as an indicator of communication in all of society, perhaps because it is closely linked to the spoken word," says Heike Nehl. Their strong grounding in typography is evident in the typeface label they created, "Face2Face" and their book *emotional_digital*, which has become a standard reference for contemporary type design. Face2Face was founded in 1993 and features the work of the well-known type designers Alexander Branczyk, Stefan Hauser, Alessio Leonardi, and Thomas Nagel. Heike Nehl and Sibylle Schlaich also design for the company, which also publishes an extraordinary "magazine", *Face2Face*, highlighting new fonts.

In this collage created by Moniteurs, the distinctive look created by the firm's mastery of type is evident on currency design, a poster illustrating a new font, and a merchandise catalogue.

Founded in 1994, *Face2Face* magazine introduces new fonts created by some of the top designers in the world. Packaged in a film canister, issue number 5 contains CD ROMs and brochures on new fonts by six designers including Thomas Nagel, Heike Nehl, Alessio Leonardi, and Sibylle Schlaich.

Creating web sites is a major component of Moniteurs' design practice.

Goethe bytes

Suchen :

sonen um Goethe |Biografie |Werke |Medien |Service |Links |Home

As book designers, one of Moniteurs
most important projects was the
design of their own book,
emotional_digital which presents
recent font design by a stellar group
of international designers. Like much
of their work, the book has a
pronounced interactive feel to it and
much of the work shown is at the
very edge of contemporary type
design.

emotional_
_digital

moniteurs

publishing and book design
client– verlag hermann schmidt mainz, 1999

IngenieurbauFührer
Baden-Württemberg

urbauFührer

_m_books
read/write/design

book design
client~ bauwerk verlag, 1999

corporate design
client~ bauwerk verlag, 1999

Corporate image campaigns created by Moniteurs usually include an interactive web design as well.

Within the SBP homepage images:

HOME — Schlaich Bergermann und Partner — INDEX — SEARCH — NEV

Beratende Ingenieure im Bauwesen

welcome
to our homepage

Schlaich Bergermann and Partners (SBP) of Stuttgart Germany are

HOME — Schlaich Bergermann und Partner — INDEX — SEARCH — NEV

Beratende Ingenieure im Bauwesen

www.sbp.de

28. 10. 1999

*KalenderBlatt

Archiv Hilfe
→

1. 2. 3. 4. 5. 6. 7. 8. 9. 10. 11. 12. 13. 14. 15. 16. 17. 18. 19. 20. 21. Jahrhundert
Januar | Februar | März | April | Mai | Juni | Juli | August | September | Oktober | November | Dezember

Geburtstage Gedenktage Zitat des Tages
 "

>1972: Airbus Probeflug

G2
Enhanced

Airbus A-300, 1972;
Quelle: dpa

Am 28. Oktober 1972 unternimmt der "Airbus" seinen ersten Probeflug. Das Verkerhrsflugzeug wird von einem Konsortium mit französischer, deutscher, britischer und spanischer Beteiligung gebaut und ist die "europäische Antwort" auf die bis dahin marktbeherrschende US-amerikanische Flugzeug-Industrie.

Mehr zu diesem Thema Themalinks

‹DW

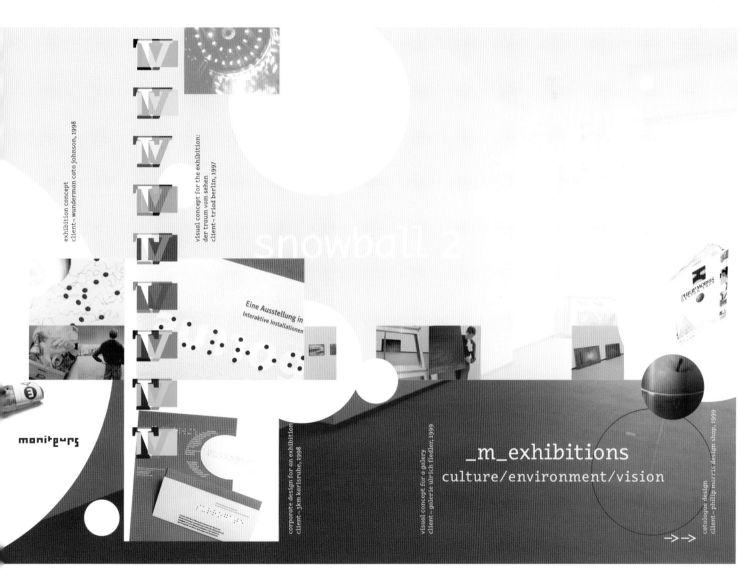

exhibition concept
client – wunderman cato johnson, 1998

visual concept for the exhibition:
der traum vom sehen
client – triad berlin, 1997

Eine Ausstellung in
Interaktive Installationen

snowball 2

moniteurs

corporate design for an exhibition
client – 3km karlsruhe, 1998

visual concept for a galery
client – galerie ulrich fiedler, 1999

_m_exhibitions
culture/environment/vision

catalogue design
client – philip morris design shop, 1999

–> –>

In this collage designed by
Moniteurs, a variety of concepts for
exhibition design are shown.

PRINCIPALS: Nicolaus Ott, Bernard Stein
FOUNDED: 1978

Bundesplatz 17
10715 Berlin
TEL: (49) 30 85 35 45 6
FAX: (49) 30 85 72 95 60
EMAIL: ott.stein@snafu.de

OTT + STEIN

From word to image and back again—that is the shortest description of the crucial step in every piece of work by Nicolaus Ott and Bernard Stein. They distance themselves from the figurative and photographic poster tradition by calculated handling of space and lettering. Both the image, when there is one, and the type are given equal presence. They work in a large high-ceilinged room that they have occupied since forming their partnership 20 years ago. There are no computers in this room—they sit opposite each other, sketching on a scale of 1:1. Working thusly, they have made an international name for themselves in graphic design. Most of their commissions are associated with culture, and they have established an unmistakable formal language that has made a crucial mark on the public image of culture in the more than 600 posters they have designed to date.

These posters demonstrate Ott + Stein's remarkable skills in integrating type and imagery.

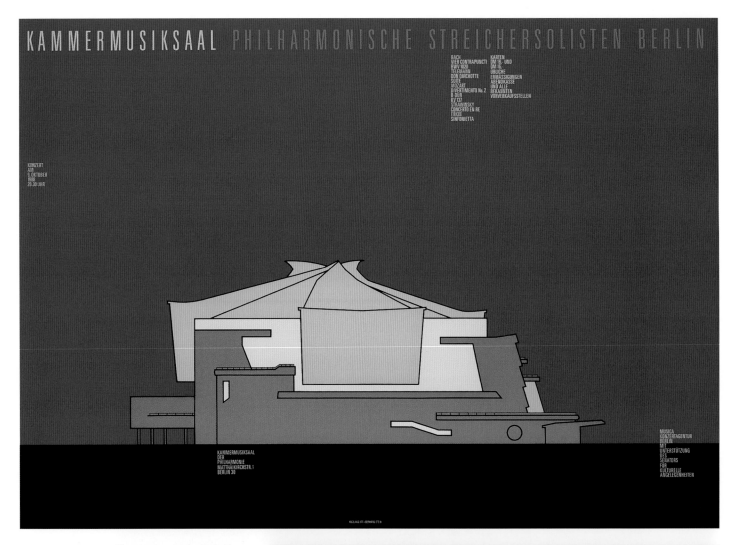

These posters are dominated by strong architectural motifs. Above is a poster for a concert by the Berlin Philharmonic featuring the Chamber Music Hall by architect Hans Scharoun.

Der Jav a Turm

Der Java Turm
Nietz Prasch Sigl
und Partner
Entwurf
Sergei Tchoban

Nicolaus Ott+Bernard Stein

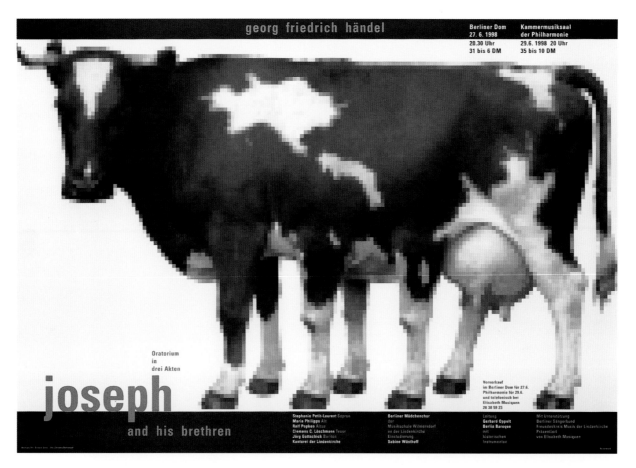

Much of Ott + Stein's work combines
formal sensibilities with great wit.

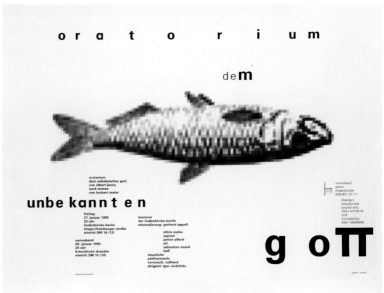

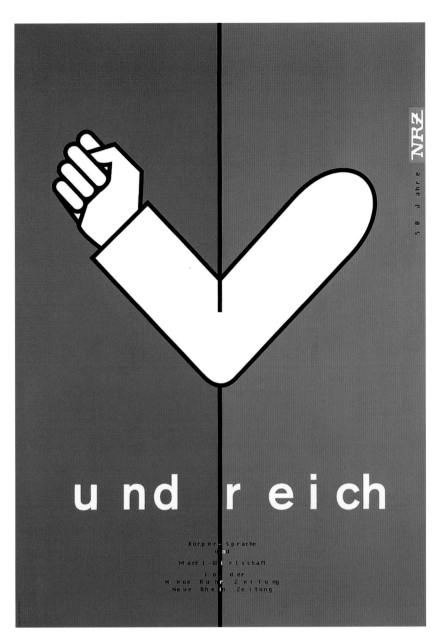

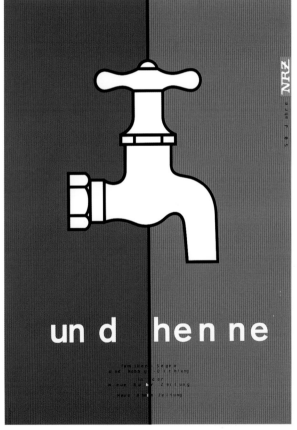

Phyllis Rose

Die Entdeckung Glücks des

Alexander Fest Verlag

In addition to the extraordinary number and range of posters that they have created, Ott + Stein design a number of book covers each year. These are for the publisher Alexander Fest.

Ott + Stein are masters of creating a structural hierarchy by staggering type sizes within carefully determined blocks. Coloring is used sparingly to give depth to the posters.

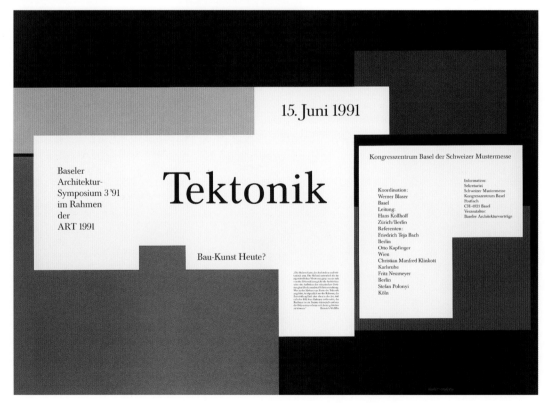

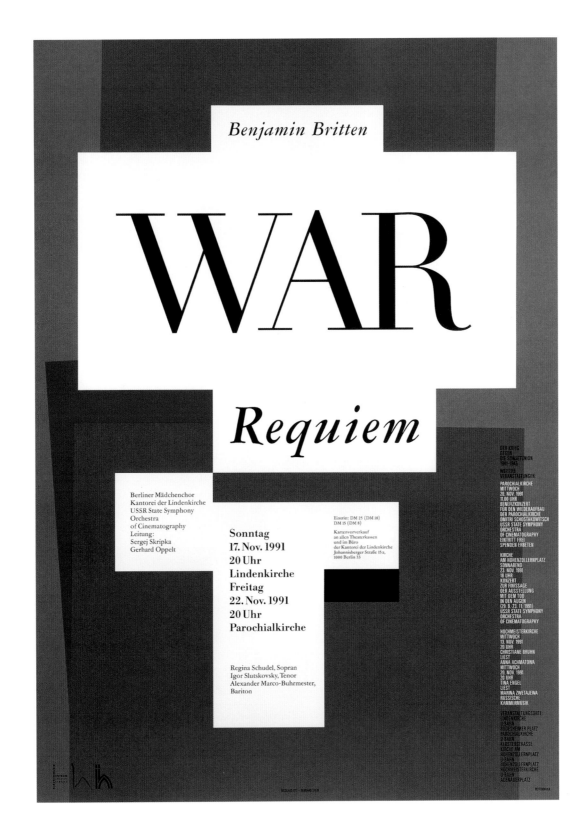

PRINCIPAL: Paulus Neef
FOUNDED: 1991

Reuchlinstrasse 10-11
10553 Berlin
TEL: (49) 30 34 98 15 00
FAX: (49) 30 34 98 14 00
EMAIL: Info@pixelpark.com
WEB: www.pixelpark.com

PIXELPARK

In October, 1999, just eight years after its founding, Pixelpark became a publicly traded company, a testament to the rapid growth of the Internet and companies that provide services for it. With eleven offices in six countries, Pixelpark provides an international clientele with communication and transaction solutions for all new media platforms. Pixelpark's name was chosen to unite what it considers the two aspects of its business. "Pixel" is the smallest element that can be portrayed on a computer screen and it stands for the technology the company develops. "Park" is seen by the company as representing a pleasant, growing environment and the human side of Pixelpark's work—creating web sites that benefit the user. As an example, the Museum of Modern Art chose Pixelpark to develop its first online store. Created in 1998, the site included a number of technological advances that aid the online shopping experience such as daily merchandise updates, a gift registry, and a "reminder" service to help users remember birthdays, anniversaries, and other special occasions.

The web sites designed by Pixelpark for the Museum of Modern Art's store focused on combining the look, feel, and functionality of an online store with MoMA's worldwide reputation as a center of design and art. Detailed product information, daily merchandise updates, and special discounts and promotions are featured. Other innovations include a gift registry, a "reminder" service to help users remember birthdays, anniversaries and other special occasions, as well as the ability to track ordered merchandise.

This web site created for Nestlé Germany is designed to be highly interactive, allowing users to join a group called Future Brand Investigators to work together to create a new product within the Nestlé product range. The targeted group for this site is 16-25 years old.

This government sponsored
interactive forum allowed users to
contribute their personal visions
of life, work, travel, and learning in
new millennium. Online chats with
experts in these fields were held to
promote interactive discussion
with site users.

habitat

Habitat introduced the public to names like the italian maestro Vico Magistretti, Britain's own Robin Day and the great Dane Hans Wegner.

designers whose work encompassed Conran's criteria of

'good practical design'.

2

This was hugely important to the ethos of Habitat.

This virtual showroom for Habitat combines images from the furniture retailer's catalogue with interactive tools, allowing the viewer to select a piece of furniture and customize its color before purchasing it from a store. To find a Habitat location nearby, users can turn to a store locator which gives contact details, directions on how to get there and a video featuring a typical store interior. The site has a strong visual appeal, combining the classic Habitat look with the new medium.

A highly interactive and flexible web site was created for Messe Frankfurt, the huge convention center that attracts the largest fairs, conventions, and exhibits from all over the world.

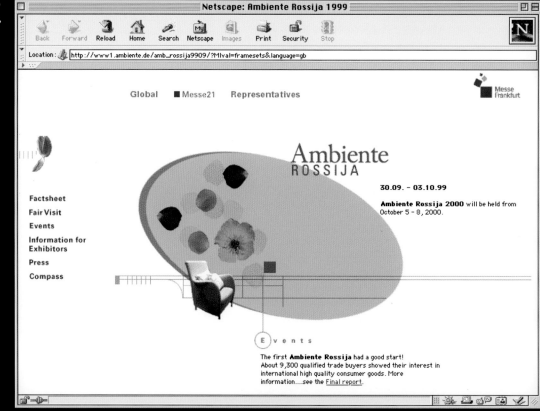

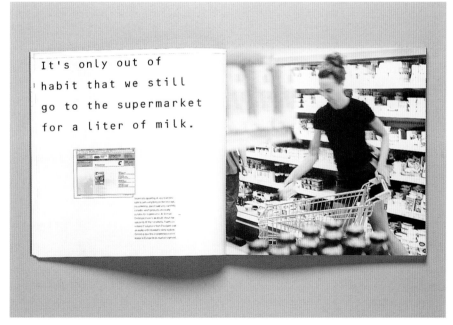

Pixelpark designed its first annual report in preparation for its initial public offering in October, 1999. The annual report was designed with the characteristics of a successful web-site in mind: clear design, easy-to-use navigation, and entertaining content. To bring a measure of interactivity into the print medium, Pixelpark designed the annual report to include two sheets of stickers of selected screenshots. Readers of the report can "interactively" paste these screenshot stickers into boxes containing the corresponding URL that can be found throughout the document.

PRINCIPALS: Sebastian Turner, Thomas Heilmann,
Jean Baptiste Bonzel, Olaf Schumann
FOUNDED: 1990

Chausseestrasse 5
10115 Berlin
TEL: (49) 30 28 53 53 00
FAX: (49) 30 28 53 55 99
EMAIL: mail @ sfberlin.de
WEB: www.sfberlin.de

SCHOLZ & FRIENDS BERLIN

Scholz & Friends was founded in February, 1990 right after the Berlin Wall came down. The three founders, Turner, Heilmann, and Schumann first set up shop in Dresden, but sensing that the action in advertising would soon be shifting to Berlin, relocated their office there a year later as did many other agencies from the US and Europe. Business proved to be elusive and many left. But Scholz & Friends flourished and today it is regarded as the first all-German agency, embracing the culture of both the East and the West. With offices housed now in what was once a coffin factory, the agency has created many memorable campaigns that often combine strong visual imagery with a liberal dose of German humor. Particularly noteworthy have been the extensive print campaigns for *Frankfurter Allgemeine* that have involved famous faces and locations around the world.

This poster is one of a series promoting editorials in the *Dresdner Morgenpost*, a daily newspaper in Dresden.
Creative Director: Sebastian Turner
Copy Writers: Nina Havlicek, Oliver Seltmann
Art Directors: Oliver Seltmann, Lutz Plümecke

[*Saturday: the F.A.Z.-Appointments section*]

One of the few jobs that are not on offer on Saturday in Europe's largest Appointments section for specialist and management staff.

Frankfurter Allgemeine
ZEITUNG FÜR DEUTSCHLAND

This print campaign was created to promote the job classifieds in the *Frankfurter Allgemeine* newspaper. It is the largest job market in Europe.
Creative Director: Sebastian Turner
Copy Writer: Robert Krause
Art Directors: Lutz Plümecke, Oliver Seltmann

[*Saturday: the F.A.Z.-Appointments section*]

One of the few jobs that are not on offer on Saturday in Europe's largest Appointments section for specialist and management staff.

Frankfurter Allgemeine
ZEITUNG FÜR DEUTSCHLAND

This print campaign, "There is always a clever mind behind it," has won numerous awards for the agency. In each case, a famous individual, whose face is obscured by the *Frankfurter Allgemeine* newspaper, is shot in a dramatic situation. This campaign promotes trust since the viewer must believe that the famous person is in fact in the shot just as the reader should trust the accuracy of the contents of the newspaper itself. The director Billy Wilder is shown in front of the Hollywood sign and Germany's former chancellor Helmut Kohl is shown on the bow of European Freeway, P & O Sea Ferries.

Creative Director: Sebastian Turner
Art Director: Petra Reichenbach
Graphic Design: Ronald Liedmeier, Frank Melzer
Design: Hans-Jürgen Gaelzner
Photographer: Alfred Seiland

Other posters in the *Frankfurter Allgemeine* campaign included the astronaut Ulf Merbold (top) and publisher Siegfried Unseld (above).

Appearing to be written by hand,
this perfect-bound brochure
promotes private banking at
Landesbank Berlin.
Creative Directors: Martin Pross,
Joachim Schöpfer
Copy Writer: Joachim Schöpfer
Art Directors: Wolfgang Ring,
Martin Pross
Photographer: Mathias Koslik
Typography: Martin Pross

In an effort to raise funds to restore the Dresden's historic Frauenkirche, Scholtz & Friends came up with the idea of giving a certificate of ownership of a fragment of the church in exchange for a donation.
Creative Directors: Sebastian Turner, Olaf Schumann
Copy Writer: Sebastian Turner
Art Director: Olaf Schumann

A safe stronghold

➤ For two centuries following the Reformation, German Protestantism did not produce an outstanding church building of its own. Indeed, why should it have? Existing churches were taken over and initially, most of the new buildings were palace chapels. ➤ But then Dresden was to see the consummation of Protestant church building. In 1712, the Hamburg architectural scholar Leonhard Christoph Sturm had demanded that "the main requirement of a church is that everyone ... can see the preacher in the pulpit." ➤ George Bähr met this requirement by creating a centralized building, the like of which Protestantism had not known before with a monumental dome soaring up over the nave. ➤ A Catholic King was one of its principal patrons. August the Strong, the illustrious Elector of Saxony, had converted to Catholicism to become King of Poland. ➤ He supported Bähr's baroque Gesamtkunstwerk and approved the construction of this "stone bell" as the pinnacle of Protestant architecture – and a symbol of Saxony's religious tolerance.

The monument to Martin Luther in front of the Frauenkirche.

The consummation of Protestant church architecture – seen from Dresden's Neumarkt.

Adopt a stone

➤ You can make the rebuilt Frauenkirche a building of your very own by adopting one of the stones. Some 45,000 cut stones will be required to rebuild the Frauenkirche. ➤ 300 cubic metres of documented sandstone were lost in the 1950s. Although some of the stones from the original building are no longer suitable for the reconstruction, all the rest are to be used. ➤ These 45,000 cut stones can be adopted. Exposed stones are available for multiple adoption.

With a Golden Dome Certificate you will receive a plan indicating where your stone has been built into the rebuilt church. ➤ So each Dome Certificate is a symbolic expression of solidarity with the reconstruction of Dresden's Frauenkirche. It does not entitle the holder to any kind of membership or property rights nor to it a security in the legal sense. However, Dresden Frauenkirche Foundation will regard all the donors as sponsors of the reconstruction concept and include them in the information process. ➤ The sum donated is tax deductible as a donation to an officially registered charity.

Nature enlivens this annual report
for the Bürgschaftsband Sachsen.
Creative Director: Olaf Schumann
Copy Writer: Sebastian Turner
Art Director: Kerstin Heymach

Scholz & Friends relies heavily on wit
and humor to get its messages
across. This print campaign for RTL
Television, called "Fascination" is
every bit as engaging as the
programming it promotes.
Creative Directors: Lutz Plümecke,
Martin Krapp
Copy Writers: Oliver Handlos,
Martin Krapp
Art Directors: Oliver Seltmann,
Lutz Plümecke, Rephael Püttmann
Photography: Nike Schmid-Burgk

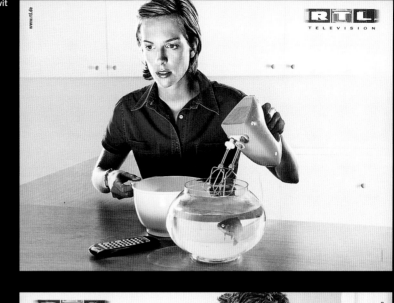

PRINCIPALS: Gundula Markeffsky,
Peter Müehlfriedel
FOUNDED: 1995

Gerichtstrasse 12/13
13347 Berlin
TEL: (49) 30 46 60 40 46
FAX: (49) 30 46 60 40 45
EMAIL: skop@skop.com
WEB: www.skop.com

SKOP

Before founding skop, both partners received their apprenticeships in print media. Markeffsky worked in print making and preproduction in Berlin while Müehlfriedel was one of the last to receive training as a typesetter with hand-set metal type in East Germany. They met at the Hochschle der Künste and soon opened a studio, first under their last names—but as they expanded the range of media in which they worked, they changed the name to skop in 1999. Most of their clients come from the cultural sectors and increasingly their work is focused on the Internet. They are particularly interested in highly experimental uses of the web and believe that the envelope should be constantly pushed towards making the web more interactive. A website they created with Leonard Schaumann (www.electrica.de) is an extraordinary experimental laboratory in sonic interactivity on the web. It uses sound samples from 1950s science fiction movies, original recordings from technical museums and other sounds. Visitors to the web site can modify the sounds as they play with them and upload these sounds for other users to hear.

A keen awareness of technology pervades much of the work of skop so it was appropriate that they were chosen to create the corporate identity program for the hands-on science museum Imaginata located in Jena. skop designed posters and brochures for the museum.

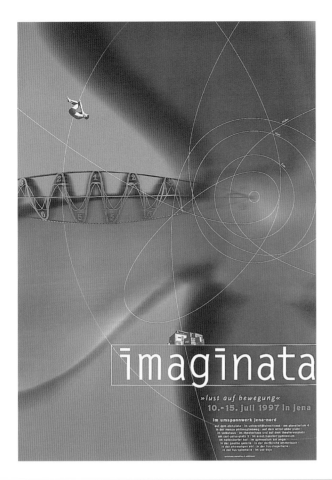

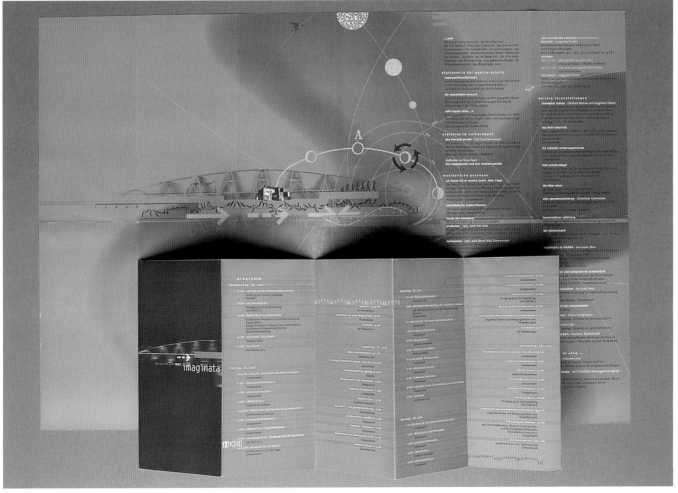

On their own initiative, Peter Mühlfriedel, Gundula Markeffsky and Leonard Schauman created "Electrica," an interactive sound web-site. On this page are invitations for the Electrica web-site release party at Kunst + Technik, Berlin as well as a flyer for the party. Opposite are screen shots from the web-site.

»A JOURNEY INTO ELECTRIC SOUND«

Electrica is an experimental lab in sonic interactivity on the web – a hommage to the sounds and graphics of electricity.

Enjoy astonishing virtual instruments, amazing sounds and sonified images!

| I | Turn up the volume! |
|---|---|
| II | Dive into the ambient industrial groove of the »elektrophone«! |
| III | Mess around with the sonic pictures at the »transformer«! |
| IV | Modulate the opulent soundspace of the »resonator«! |
| V | Become instantly an avantgarde composer with the surprising acoustic variety of the »theremator«! |
| VI | Move the electrographic audioscape at »netzbrummen« and enjoy visualized gif-animated sounds! |

Electrica requires:
Netscape/Explorer 4.0 or higher,
the Beatnik plug-in
(directly downloadable for free),
HiFi speakers,
prefers 100 Mhz or faster processor.

www.electrica.de

skop 46604046 © 1999 skop + leonid, berlin leonid 28598730

Spreads from *Häutungen*, a book on
skin with lyrics by Stefan Wieszner.

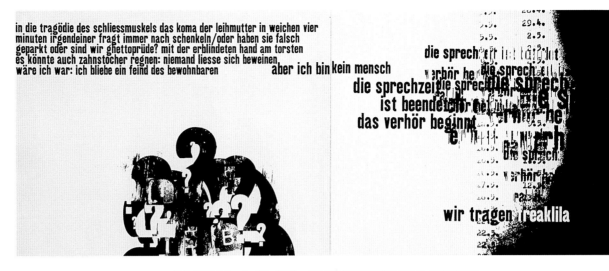

Spreads from *Nichts Sein Sein Nichts*, a book based on a poem by the East German writer Matthias Baader Holst.

PRINCIPALS: Nicholas Marek Kapica, Burkhard Kieker
FOUNDED: 1995

Oranienburger Strasse 87
10178 Berlin
TEL: (49) 30 30 87 28 18
FAX: (49) 30 28 11 24 1
EMAIL: buero@standige-vertretung.com

STANDIGE VERTRETUNG

Standige Vertretung began in 1989 as a dance club co-founded by Nicholas Kapica. When he established a graphic design studio in 1995, he decided to retain the name. Like a carefully mapped dance step, Standige Vertretung prefers a design esthetic that is pure and simple. Kapica also believes in the importance of a good design briefing. The creation of a way of communicating with surrounding neighborhoods about the coming of a new airport for Berlin is typical of the problem solving skills of the agency. The new airport will replace Berlin's existing three small airports that are inadequate for the rapidly growing city. It was decided that the best way to inform the neighborhoods would be to visit them directly. A typical airport bus was fitted with facilities to show videos, plans and drawings of the new airport. To attract attention, Standige Vertretung applied icons normally associated with signage at airports on the outside of the bus to locate the entrance and identify the content. The result has been a significantly increased awareness of the new airport and how it will impact the surrounding community.

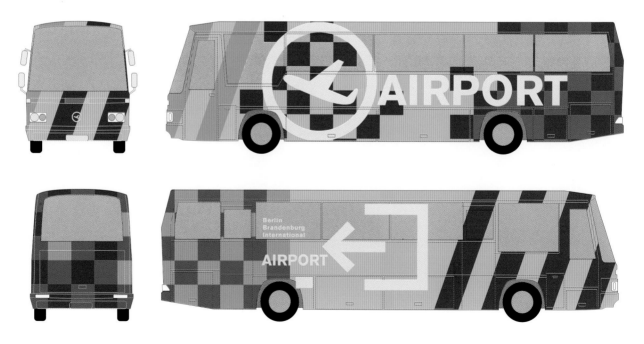

Airport icons adorn the bus designed to serve as a mobile exhibition center to inform surrounding neighborhoods about the new airport.

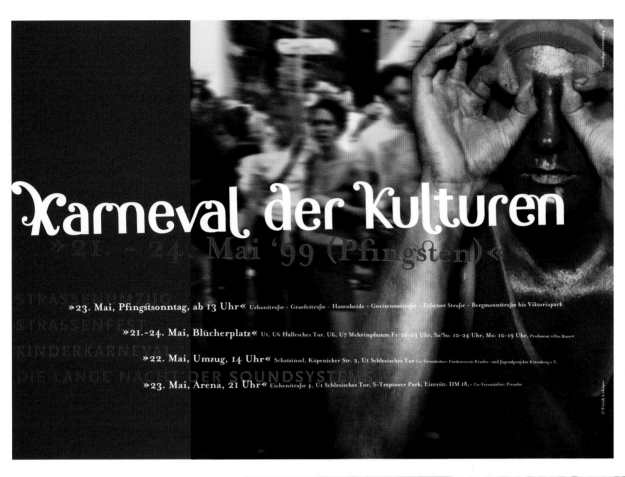

For this identity campaign for a carnival in Berlin, Standige Vertretung created a dancing "K" that forms the core of the campaign. The letterform needed to address the many different cultures in Berlin as well as recognize the tradition of German carnivals. For some, the "K" dances while for others, it resembles the traditional German carnival hat.

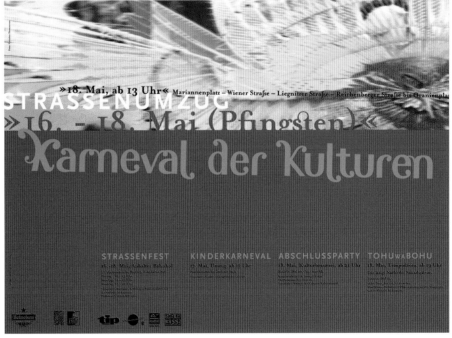

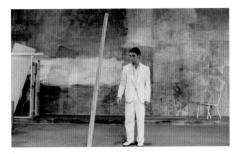

Postcards (right) and posters (left) were created for the dancer and choreographer Sasha Waltz. Blue is the dominant color. The photography was commissioned. The typography for the posters was chosen to express dance.

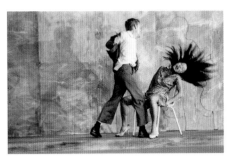

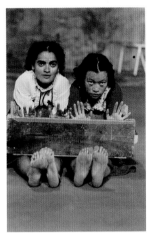

This is part of a temporary signage system for a three-day conference held in the Haus der Kulturen der Welt. The conference theme was Type & Image. The signage consisted of a color scheme with typography. Dot screen images identified the entrances to particular rooms. At a distance the images could be seen. Close up, the images broke up into abstract dots allowing the typography to be read.

This book documents a conference called "Type is Money". On the front cover, the book's title is subservient to the names of the participants. Inside, the book was divided into sections for each speaker marked by a color band and portrait photo. The typeface Akzidenz Grotesk medium was used for all of the copy.

Ich finde es wirklich erschreckend, daß nur eine einzige Frau an diesen drei Tagen einen Vortrag hält. Was der Spiekermann da behauptet, daß es so schwierig wäre, Frauen zu finden, die in der Öffentlichkeit etwas sagen wollen – so nach dem Motto, die trauen sich nicht –, das kann ich einfach nicht glauben. Sarah Dorkenwald, Grafikerin, 26 Jahre

It's really scary to me that over a three day period there's only a single woman holding a lecture. What Spiekermann claims, that it's supposedly so difficult to find women who want to say something in public – following the motto: they don't dare – is just simply unbelievable to me. Sarah Dorkenwald, graphic designer, 26 years

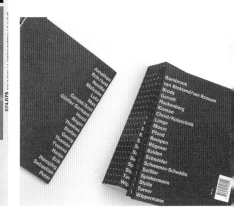

...onscript is very loosely based on a ...ce of lettering seen on an old 1960s ...era bought in a junk shop. It is ...ography that mixes vatican values ...n a maxime like »the price is right«. ...e glitches on a lie detector print out

...script erinnert entfernt an eine Aufschrift auf einem Photoapparat ...n 60er Jahren, der in einem Trödelladen erstanden wurde. Es ist ...ypografie, die die Werte des Vatikans mit einer Maxime wie »Der ...stimmt« mixt. Nixonscript ist wie die jähen Ausschläge auf dem ...uck eines Lügendetektors – sie eignet sich für Lügengeschichten.

It takes One mu...
effort to... invest t...
...rstanding ...to a...u
...equires of type underst...
den Zugang zur Schri
k.

PRINCIPALS: Udo Albrecht, Holger Stumpe
FOUNDED: 1998

Schönhauser Allee 74a
10437 Berlin
TEL: (49) 30 44 73 10 13
FAX: (49) 30 44 73 10 17
EMAIL: stereobloc@rocketmail.com
WEB: www.stereobloc.de

STEREOBLOC

When Udo Albrecht and Holger Stumpe decided to open their design studio, they knew that the former East Berlin was the location for them. The rough, industrial-like studio space they eventually chose in Prenzlauer Berg suited their intention of being a creative factory, not an advertising agency. The two are inspired by the subcultures of Berlin, particularly the music scene (hence, stereobloc). "The city influences our style," says Stumpe, "it is bitter and sweet, hard and soft, techno and soul, expensive and trashy. By the rhythm of our creations we try to transport brief information through emotional atmospheres. Undefined images and strange colors may stand side by side with high typography—or the other way around." stereobloc's design approach is to work out concepts for projects by considering content, creation, and realization as a whole. "We hate the situation graphic designers often find themselves in when they work for a conventional advertising agency where creativity is the last step before production after everything has been planned by management and marketers."

CD cover designs for German punk rock bands. The CD below has no title, leaving the designers completely free to create a cover with no thematic purpose. Portions of lyrics for some of the songs are reproduced across the top.

Adriana
Lubowa
Lieder kurz nach dem Glück

Piano Matthias Binner
Lichtgestaltung/Ton Roberto Beer

ne Co-Produktion
r Bar jeder Vernunft, Berlin,
nd Adriana Lubowa

anagement
unstStück Uwe Berger, Berlin
l (030) 45 19 94 91

Kunst
Stück

These posters announced the return
of a popular singer of Russian and
German music after a three-year
absence. The photography is by
Thomas Zebisch and Jörg Dederling.
Clever use of the color orange links
the two images.

Roberto Beer (Lichtgestaltung/Ton)
KunstStück Uwe Berger, Berlin
Tel (0 30) 45 19 94 91 (Management)
Präsentiert von
BerlinOnline TV.BERLIN

Welturaufführung
17. Februar bis 6. März 99
mittwochs bis sonntags
BKA Theater
Mehringdamm 34
10961 Berlin-Kreuzberg
Kartentelefon (0 30) 2 51 01 12

Matthias Binner (Piano) ADRIANA
LUBOWA
RAZZIA IM
PARADIES
Chansons

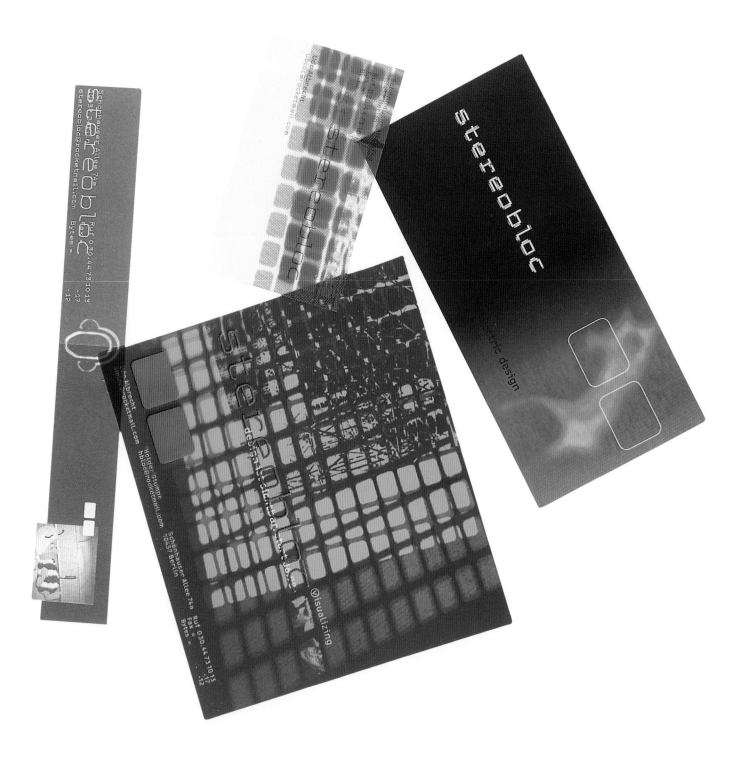

Business cards and flyers promoting
sterobloc also provide a good idea of
the range of the partners' creative
abilities.

stereobloc developed the entire
corporate design campaign for the
fifth annual FontShop Conference
Typo 2000 "Styles". The congress is
the most important meeting of
designers in Europe.

Stationery and letterhead design features bold yet simple images to convey the primary activities of the clients for whom sterobloc works.

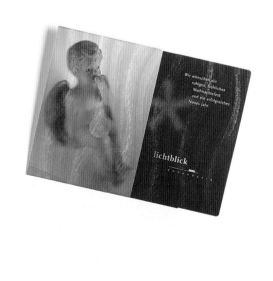

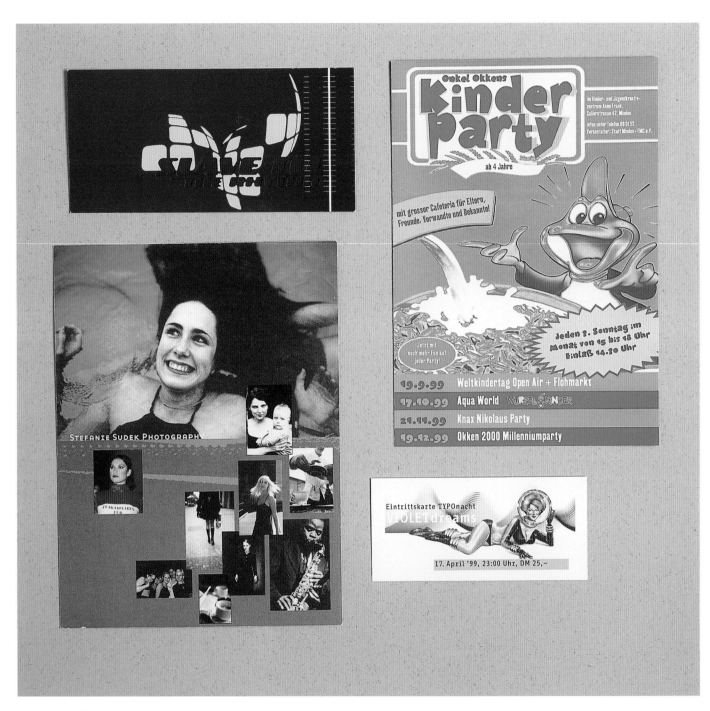

The partners report that some of the most creative and enjoyable work comes from designing low-budget postcards, flyers, and party invitations for a number of clients.

New FontFont Release

1/2000
1/2000
1/2000
1/2000
1/2000
1/2000
1/2000
1/2000
1/2000
1/2000
1/2000
1/2000

Archian
Backbone
Backstage
Beekman
Letter Gothic Slang
Super Grotesk
Super Grotesk Condensed
TradeMarker

This poster (left) presents a new collection of fonts released by FontShop International. The release date 1/2000 is used to illustrate the new fonts. The Media Lounge (below) is a forum where media professionals mentor young entrepreneurs. The logo created by stereobloc symbolizes this process.

media~lounge

PRINCIPALS: Joachim A. Buroh, Stefanie Giersdorf,
Magnus Hengge
FOUNDED: 1994

Pfuelstrasse 5
10997 Berlin
TEL: (49) 30 53 69 51 57
FAX: (49) 30 53 69 51 58
EMAIL: studioadhoc@bln.de
WEB: www.studioadhoc.de

STUDIO ADHOC

Clients of studio adhoc can be sure of no strict style as evidenced in the choice of the firm's name, ad hoc, a Latin word meaning "not pre-arranged." At studio adhoc, the design strategy is closely tied to the clients' communication objectives, such as the design for a magazine sponsored by Berlin's largest event hall, Arena. The magazine, titled *Arena Berlin Operator*, focused on underground trends in music and fashion and promoted the acts held at the Arena. studio adhoc

wanted the advertisements to be completely integrated into the content of the magazine. The result is a seamless blending of editorial and advertising, a mixture of hand-crafted collages and techno-computer design. studio adhoc created two new fonts for the magazine, Arenago and Arena Trade.

The magazine *Arena Berlin Operator* is a collage of advertising and editorial. The magazine focuses on underground trends in lifestyle, music, fashion, and leisure and promotes performing acts held at the Arena. The fonts are by Magnus Hengge with photography by Miriam Braig of Hamburg.

Kim Myungphyo (1947-) **Minyo 3 Djang** [8'02"] (first recording)
1 Moderato [3'55"]
2 Andante espressivo [3'01"]
3 Allegretto [3'06"]

Guitar Duo
LEE SONG-OU & OLIVER FARTACH-NAINI

total playing time [53'27"]

Stephen Dodgson (1924-) **Take Two** [9'31"] (first recording)
4 A quiet moment [1'39"]
5 Valse triste [1'03"]
6 Ambling [3'13"]
7 Cantilena [1'45"]
8 Friendly Combat [1'51"]

Lee Hunghyun (1957-) 9 **Kyunwoo and Jignyo** [2'28"] (first recording)
10 **The Milky Way** [5'14"] (first recording)

Jaime Mirtenbaum Zenamon (1953-) **Sonata Andina** [16'04"]
11 Vivo [3'31"]
12 Lento [7'17"]
13 Bien Animato [5'16"]

Lee Geonyong (1947-) 14 **Movement for two guitars** [12'08"] (first recording)

Instruments: Rolf Eichinger, Achim-Peter Gropius
Tonmeister: Joachim Goßmann
Recorded: March 1997 in Berlin
Cover Design: studio adhoc, Magnus Hengge

LC 2555
Best.Nr. kr 10020

movement FOR TWO GUITARS

LEE SONG-OU & OLIVER FARTACH-NAINI

Suite Buenos Aires **Máximo Diego Pujol** (*1957) 16'59''
Pompeya 4'22''
Palermo 4'58''
San Telmo 3'27''
Microcentro 4'12''

Tango Etude No. 3 **Astor Piazzolla** (1921 - 1992) 3'52''
Solo Flute

Don Mondongo **Gabriel SenaneS** (*1956) 6'04''
World Premiere Recording

Preludio Tristón **Máximo Diego Pujol** (*1957) 4'09''
Solo Guitar

Histoire du Tango **Astor Piazzolla** (1921 - 1992) 22'09''
Bordel 1900 4'04''
Café 1930 7'11''
Nightclub 1960 5'49''
Concert d'aujourd'hui 5'05''

Total playing time 53'21''

Recorded: April 1998 at Ballhaus Naunynstraße, Berlin
Artistic Production and Supervision: Marcus Waibel
Guitar: Achim-Peter Gropius
Flute: Altus 1607
Cover Design: Magnus Hengge, studio adhoc, Berlin
Coverphoto: Klaus W. Eisenlohr

LC 02555 GEMA KR 10039
4 026404 600390

Altus

Suite Buenos Aires
ARGENTINIAN MUSIC
FOR FLUTE AND GUITAR
PIAZZOLLA
Thea Nielsen
Oliver Fartach-Naini

Using a painting by Peter Crockett,
these CDs are a mixture of ethnic
music and modern compositions
from Korea and Argentina.

LEE SONG-OU & OLIVER FARTACH-NAINI

movement FOR TWO GUITARS

LC 2555 GEMA
Bestell-Nr: kr 10020

Kim Myungphyo **Minyo 3 Djang**
Stephen Dodgson **Take Two**
Lee Hunghyun **Kyunwoo and Jignyo**
The Milky Way
Jaime Mirtenbaum Zenamon **Sonata Andina**
Lee Geonyong **Movement for two guitars**

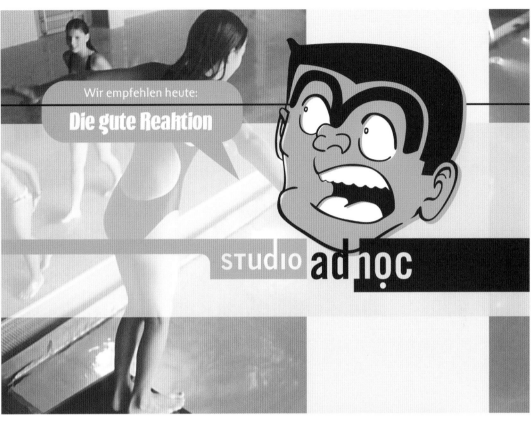

Self-promotional cards rely upon
humor to get their messages across.

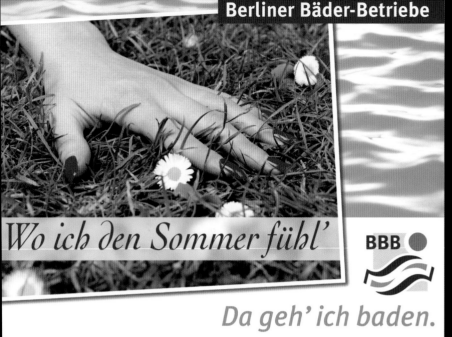

Berliner Bäder-Betriebe

Wo ich den Sommer fühl'

BBB

Da geh' ich baden.

Berliner Bäder-Betriebe

Wo ich den Sommer fühl'

BBB

Da geh' ich baden.

Berliner Bäder-Betriebe

Wo ich den Sommer fühl'

BBB

Da geh' ich baden.

Berliner Bäder-Betriebe

Wo ich den Sommer fühl'

BBB

Da geh' ich baden.

studio adhoc designed the complete
corporate image campaign for the
city agency responsible for the many
municipal swimming pools in Berlin.
These are billboards which were
used as part of a summer campaign
to promote the pools.

In the culture arena, studio adhoc was responsible for the corporate design for the Brandenburgische Philharmonie Potsdam. Details of musical instruments as well as photography of the orchestra members enhance these program notes.

PRINCIPALS: Michaela Booth, Inken Greisner,
Theres Weishappel
FOUNDED: 1999

Kurfürstenstrasse 33
10785 Berlin
TEL:(49) 30 25 79 78 94
FAX:(49) 30 26 28 01 7
EMAIL: all@typoly.de
WEB: www.typoly.de

TYPOLY

As with many graphic designers in Berlin, Inken Greisner and Theres Weishappel first worked at MetaDesign where they met in 1987. They left in 1989 to establish their first graphic design firm, and then last year founded Typoly with Michaela Booth, the former art director of Rotbuch Verlag. The partners take a very systematic approach to their work which includes corporate design, publications, illustrations, and Internet sites. Children are the focus of much of their design work.

Typoly employs a four step procedure for creating graphic materials for their clients. First comes a targeted consultation, "a good briefing forms the basis for every graphic design." Next is a market analysis, "how can we help our clients reach their target groups effectively?" The third step is actually designing the creative materials for the client. Finally, they work to insure economical production of the materials that have been created, "Visual communication starts with direct, personal contact with clients...it ends with top quality product completion, which means total satisfaction," says partner Inken Greisner.

Good design begins at home as is evidenced by the logo, stationery and business cards the designers created for their own company.

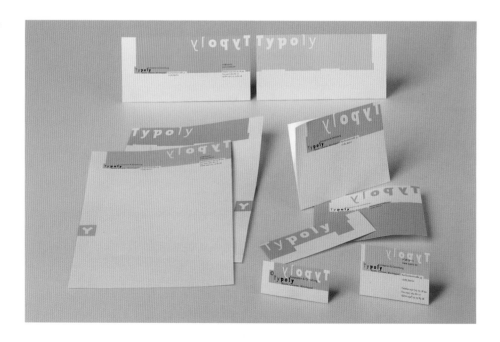

In creating the corporate design for
an organization for parents (above),
Typoly was responsible for designing
stationery, the newsletter, and
brochures. A corporate campaign
for a film development company
included designing ephemera
as well.

This exhibition design (above) about hearing and listening was for a children's museum. An interior design firm (right) engaged Typoly to create a complete corporate design program including a catalogue.

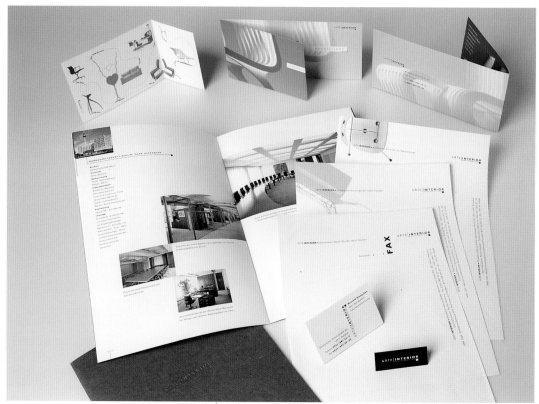

The partners of Typoly have designed book jackets for a variety of German publishers.

About the Author

James Grayson Trulove is a publisher, editor, and author in the fields of landscape architecture, art, graphic design, and architecture. He has served as editor-in-chief of *Landscape Architecture, Graphis,* and *Garden Design* magazines. He was publisher and co-founder of Spacemaker Press, an imprint specializing in books on landscape architecture. Recent books by Trulove include *The New American Cottage* and *Big Ideas for Small Spaces: Studio Apartments*, both co-authored with Il Kim; *The New American Garden; Ten Landscapes: Raymond Jungles; Ten Landscapes: Shunmyo Masuno;* and *Big Ideas for Small Spaces: Pocket Gardens.*

Trulove received degrees from the University of North Carolina, Chapel Hill; The American University; and Johns Hopkins University. He is a recipient of the Loeb Fellowship from Harvard University's Graduate School of Design. He resides in Washington, D.C., and New York.